The DK *Art School*

WATERCOLOR
COLOR

The DK Art School

WATERCOLOR
COLOR

EDITORIAL CONSULTANT RAY SMITH

DK

DORLING KINDERSLEY
LONDON • NEW YORK • STUTTGART
IN ASSOCIATION WITH THE ROYAL ACADEMY OF ARTS

A DORLING KINDERSLEY BOOK

Project editor Susannah Steel
Art editor Des Plunkett
Assistant editor Joanna Warwick
Design assistant Dawn Terrey
Senior editor Gwen Edmonds
Senior art editor Toni Kay
Managing editor Sean Moore
Managing art editor Tina Vaughan
US editor Laaren Brown
DTP manager Joanna Figg-Latham
Production controller Helen Creeke
Photography Phil Gatward
Additional photography Tim Ridley,
Steve Gorton

First American Edition, 1993
2 4 6 8 10 9 7 5 3 1

Published in the United States by
Dorling Kindersley, Inc., 232 Madison Avenue
New York, New York 10016

Copyright © 1993
Dorling Kindersley Limited, London

Published in Great Britain by Dorling Kindersley Limited.
Distributed by Houghton Mifflin Company, Boston

ISBN 0 7894 3292 7 PB

First paperback edition 1998

Library of Congress Cataloging-in-Publication Data

Smith, Ray, 1949-

 Watercolor color / editorial consultant: Ray Smith. -- 1st American ed.
 p. cm. -- (The DK art school)
 Includes index.
 ISBN 1-56458–276–0
 1. Watercolor painting--Technique. 2. Color in art. I. Title.
II. Series.
ND2422.S66 1993
751.42'2--dc20 92-38771
 CIP

Color reproduction by Colourscan in Singapore
Printed and bound in Italy by Graphicom

CONTENTS

INTRODUCTION

COLOR IS A POWERFUL COMPONENT of any painting. It communicates the mood and message of a picture by making an immediate impact on the senses, and it conditions a variety of emotional responses. Artists often overlook the theory behind color, yet even the most practiced of painters may not understand why the colors in a painting do not work or why mixing colors can be so problematic. This book sets out the theory of color in watercolor painting from the basic principles of mixing pigments to more advanced methods of painting with pure, expressive color.

A refracting glass prism disperses white light into its component colors.

White

Orange-Red

Red

Yellow

Blue-Violet

Green

Blue

Additive color mixing

Isaac Newton determined that if another prism is placed in the path of the colored rays, these parts can be reconstituted as white light. It was later established that three lights are necessary to create white light – blue-violet, green, and orange-red – and that mixing two of these lights produces a new color *(see above)*. This process is called additive color mixing.

The color spectrum

Isaac Newton (1642–1727) was the first to make a scientific study of the nature of white light and, in 1666, discovered its component parts. He positioned a glass prism in the path of a beam of light shining through a small hole in a shuttered window. The emerging rays from the prism fell on to a white surface and separated into a vivid array of colors – red, orange, yellow, green, blue, indigo, and violet – that together form the color spectrum. Newton had discovered that there is no light without color and no color without light.

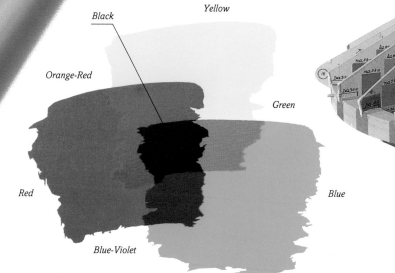

Black

Yellow

Orange-Red

Green

Red

Blue

Blue-Violet

The impact of Newton's color theory

The results of Newton's investigations with dispersed colored light appeared to have no impact on the contemporary art world, which would not take his findings seriously. Although Newton's theory of colored light provided a powerful explanation of the inextricable relationship between light and color, artists made little attempt to relate it practically to color mixing until the 1700s.

Subtractive color mixing

In 1730 a German engraver, Jakob Le Blon (1667-1741), distinguished between the component colors of light and the colored pigments in paint. Le Blon found that any color could be mixed from three "primary" pigments of red, yellow, and blue. The more pigments that are mixed together, the more light is absorbed, and the darker the paint. This is the reverse process of the additive theory of light.

From dyes to pigments

Many artists' pigments were traditionally derived from dyes of organic materials, such as mollusks, insects, and plants. It took thousands of tiny Murex shellfish to produce enough Tyrian Purple dye for just one Roman robe. These dyes were turned into pigments by being chemically fixed onto an inert base, such as chalk. George Field (1777-1854), a nineteenth-century English color maker, specialized in the manufacture of Madder Lake pigments. In his 1806 notebook *(right)*, he pressed samples of a madder plant found growing in the wild. The pink bow was painted with pigment from the wild plant.

Cochineal beetles

These beetles are the source of Carmine, an extremely fugitive color. They are collected in Peru and the Canary Islands and are dried and crushed to produce the red dye.

The decline of plant sources

Until the nineteenth century, only a few hundred natural dyes were commonly used for paint pigments. Madder plants were among the most sought-after coloring matter, and the dye extracted from the madder root had been used in textile dyeing since Egyptian times. The popular demand for madder dye led to the cultivation of huge fields of the plant in Holland. Madder roots were pounded and simmered to extract Alizarin dye, which was turned into pigment. The commercial manufacture of madder for artists' colors began at the turn of the nineteenth century, but in 1868 Alizarin was successfully synthesized, and two years later the madder fields went out of production.

Madder Lake pigment

Madder root

The color wheel

When Newton's light spectrum was joined into a color wheel by linking red and violet *(see* p.10), artists could begin to understand the practical relationship of colors. The color wheel has been developed in varying degrees of complexity, and color trees such as this one have been invented in the twentieth century to organize the full spectrum and dimension of color and turn theory into practical application. This tree incorporates the color wheel on a horizontal axis, with the lightness or darkness of each color on a vertical axis. The squares graduating toward the middle illustrate the subtractive quality of each color as it is successively darkened with gray.

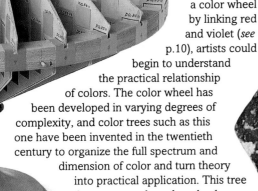

Color tree

Saffron

Made from the dried stigmas of *Crocus sativus*, Saffron was a deep transparent yellow pigment that faded rapidly.

Lapis Lazuli

This semi precious stone produced the most highly prized of traditional pigments, Ultramarine. The ground mineral, mixed into a resinous paste with oil and gum, was kneaded in water; the color that escaped was turned to pigment.

The Expansion of Color

Toward the end of the eighteenth century, the production of artists' color pigments began to improve considerably, and the previously limited range of available pigments was enlarged by a new range of bright, rich synthetic pigments, such as Chrome Yellow and Cobalt Blue. Oil had long been considered a much more sophisticated medium to paint with, and watercolor painting had existed mainly as a vehicle to color in draftsmen's topographical drawings, as well as for sketches or cartoons for oil paintings. However, a developing interest in watercolor and color theory, combined with the improvement in pigments, encouraged more artists to experiment with the medium. By 1800, a new-found confidence in the art of watercolor meant that it soon became fashionable.

Indian Yellow

This pigment was produced from the urine of cows denied water and fed only on mango leaves. The urine was mixed with earth, heated and dried, and then pressed into lumps. Deemed inhumane, its manufacture was banned in the early twentieth century.

Malachite

Inorganic materials such as this mineral are ground first into a fine powder and then bound with gum arabic.

Terre Verte

This blue-green iron oxide earth pigment, found in Cyprus and France, was one of the first pigments used by watercolor artists.

Raw Sienna

This yellow-brown pigment made from iron-rich Italian clay, became popular in England after watercolor artists first toured Europe.

Prussian Blue

This strong deep blue, synthesized and introduced in the 1720s, soon became a popular pigment because of its versatility and high tinting strength.

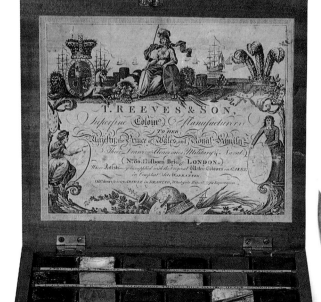

The portability of watercolor

That watercolor became such an attractive and fashionable medium in the late eighteenth century was due partly to its portability. Paint boxes such as this Reeves watercolor cake box of the early 1790s gave artists the freedom to travel and record their experiences visually. This new passion for watercolor painting that swept across Europe was motivated both by its accessibility and by the development of color. Heralded by J.M.W. Turner (1775-1851), and his contemporaries, artists of the period chose to reject the reasoning and rationale of established art, relying on color to express more emotional and intuitive attitudes.

The most popular nineteenth century brushes were made from pure Kolinsky sable.

Nineteenth century palette

A typical nineteenth century watercolor palette might comprise Chrome Yellow, Cobalt Blue, Prussian Blue, Raw Sienna, Rose Madder (Genuine), Burnt Umber, and Venetian Red. This range gave good mixing possibilities.

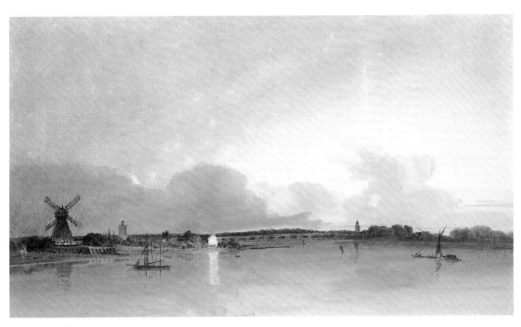

The English artist Thomas Girtin (1775-1802) revolutionized the topographical drawing into a much more expressive medium. A contemporary of Turner, Girtin was one of the first artists to interpret nature rather than record it. This work illustrates how Girtin abandoned the use of gray underlayers of paint, allowing the light to shine through transparent washes and reflect off the biscuit-colored paper. The untouched paper of the white house also creates a daringly atmospheric scene. Turner said of Girtin's talent and untimely death, "had poor Tom lived I should have starved."

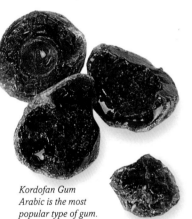

Kordofan Gum Arabic is the most popular type of gum.

Gum arabic
The solid, separate particles of color pigment are bound together by gum arabic. This gum is collected from the African acacia tree.

Gum Tragacanth thickens gum arabic.

Pigment development
Traditional pigments such as Blue Verditer, Smalt, and Dragon's Blood had completely disappeared by the end of the nineteenth century and were not replaced by new pigments until much later. Clean, lightfast synthetic pigments now replace Rose Madder, Gamboge, and Carmine, but they can still be purchased in their natural form.

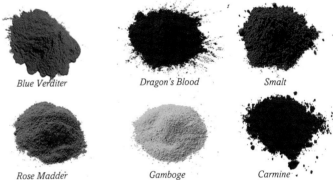

Blue Verditer

Dragon's Blood

Smalt

Rose Madder

Gamboge

Carmine

French Ultramarine

Winsor Red

Cadmium Yellow

Modern pigments
The breakthrough in artificial pigment production has transformed the color industry. Twentieth century dyes from which pigments are made are compounded from petroleum products; by 1980, as many as three million dyes were available.

THE LANGUAGE OF COLOR

THE TERM "COLOR" is a broad concept that encompasses three qualities of tonal value, hue, and saturation – or degree of lightness or darkness, innate color, and intensity. Mixing a small selection of pure paints gives unlimited possibilities for strong, vibrant colors.

Newton's theory that color coexists with light is a fundamental principle in painting. Transparent watercolor pigments allow light to reflect off the surface of the paper through the paint, so that the pigments appear luminous. Based on the principle of subtractive color mixing (*see* p.6), watercolor painting is the gradual process of subtracting light as more washes of color are painted.

Hue
Hue describes the actual color of an object or substance. Its hue may be red, yellow, blue, green, and so on.

Tonal value
Tonal value refers to the lightness or darkness of a color, according to the degree of light shining on it.

Saturation
This is the purity of a color in terms of its maximum intensity. It is unsaturated if painted transparently or mixed with white to give a tint, or mixed with a dark hue to give a shade.

Local color is the actual color of an object, or the familiar color associated with that object, independent of the effects of light.

Primary

Primary

Primary

Primary

Lemon Yellow Hue

Cadmium Lemon

Winsor Green

Cadmium Yellow

Winsor Blue

Cadmium Orange

Cerulean Blue

Cadmium Red

French Ultramarine

Permanent Rose

Cobalt Blue

Permanent Magenta

Cobalt Violet

Watercolor pigments are available in tubes or in solid pans. Tubes are slightly preferable for mixing larger quantities of wash, but the same watercolor techniques can be used with either type of paint.

Mixing with three primary colors
It is possible to mix a full complement of relatively pure colors from three primary pigments: Permanent Rose, Winsor Blue, and Cadmium Lemon *(above)*. To mix a range of clean, pure colors requires much skillful practice, as each new color uses different quantities of each primary.

Commercial colors *(left)*
The alternative to repeatedly mixing primary pigments is to choose a limited number of commercial colors that are lightfast, or permanent. These paints mix well to give a range of clean colors. It is worth practicing mixing with just a few colors, although some beautiful colors, such as the earth pigments, cannot easily be mixed from this range.

Convincing studies can be painted by maximizing the range of just one color. Light tints give highlights while washes of stronger color absorb more light to give shades.

Yellow pigments

Discovering the range of just one color, or using a limited range of colors to mix with, is a vital aspect of learning about the power of color. Yellow is a strong primary color that can range from a bright, luminous tint to a duller, heavier shade. Cadmium Yellow, used to paint this lemon peel, is a warm yellow that leans toward orange, while Cadmium Lemon is a bright golden yellow. Lemon Yellow Hue is a powerful pigment with a cool, greenish yellow effect that is both clean and pure.

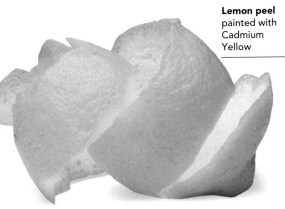

Lemon peel painted with Cadmium Yellow

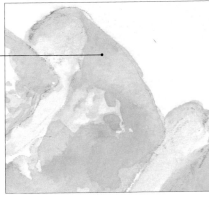

Before painting an object, it is important to consider how its tonal range varies – how light or dark its color is.

Coffeepot painted with Cadmium Red

Red pigments

Some pigments have a higher tinting strength than others, and a small quantity of paint gives a pure, intense color on paper. Cadmium Red, an opaque orange-red pigment with a high tinting strength, gives this coffeepot a rich, red quality and strong depth. Permanent Rose and Alizarin Crimson, with their cool violet quality, have a natural transparency that makes them ideal for thin glazes. They also have a good tinting strength, and so are hard to remove without staining the paper.

Test the tinting strength of each color on rough paper first to see how powerful the tints and shades appear.

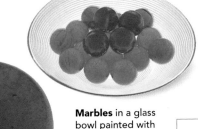

Marbles in a glass bowl painted with French Ultramarine

Blue pigments

The French Ultramarine pigment used to paint these marbles is a pure, durable, warm blue with violet undertones and a high tinting strength. It should be used carefully, as it can easily overpower other hues. Permanent colors, such as cool Winsor Blue and Cerulean Blue, are also lightfast and retain their purity of color. However, some pigments such as Manganese Blue are only moderately durable and will in time fade.

11

COLOR MIXING

BY MIXING THE THREE PRIMARIES in different combinations, a whole spectrum of color can be created. If any two of the primaries are mixed together, a "secondary" is produced. The three primaries of red, yellow, and blue, mixed in the combinations shown below, produce secondaries of orange, green, and violet. Each secondary color lies opposite the third unmixed primary on the color wheel, so that the green produced by mixing blue and yellow, for instance, lies opposite the third primary, red (*see* p.13).

Cadmium Red *Cadmium Yellow*

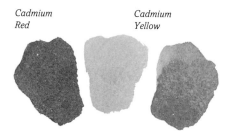

Equal quantities of Cadmium Red and Cadmium Yellow pigment, mixed together on a palette, give a warm orange hue.

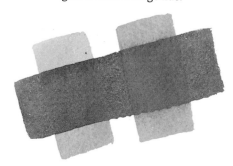

A secondary hue can also be produced by laying a wet wash over a dry wash. This orange is brighter than if mixed on a palette.

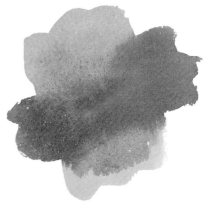

A third way of mixing pigments to create a new color is to allow very wet washes of each color to bleed together randomly.

Cerulean Blue *Lemon Yellow Hue*

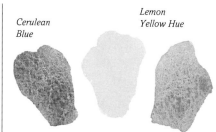

The primary pigments of Cerulean Blue and Lemon Yellow Hue mix together effectively to produce a sharp acid green.

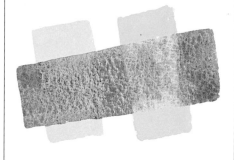

The vertical wash on the left lies below the horizontal wash, while the right wash on top gives a slight contrast in appearance.

This wet-in-wet technique creates spontaneous mixes of color of varying strengths and tones.

Alizarin Crimson *French Ultramarine*

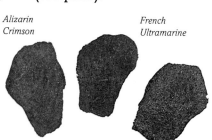

A warm, rich violet color can be produced by physically mixing Alizarin Crimson and French Ultramarine.

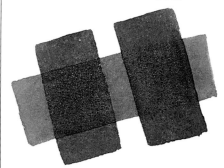

This wet-on-dry method of mixing on the paper retains the purity of each pigment, and the resulting color is more intense.

The colors will flood effectively if the paper is first dampened or if the pigments are mixed with plenty of water.

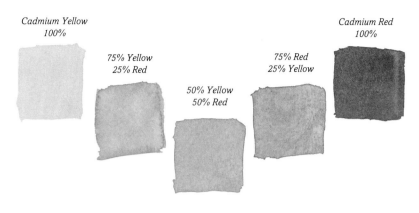

Cadmium Yellow
100%

75% Yellow
25% Red

50% Yellow
50% Red

75% Red
25% Yellow

Cadmium Red
100%

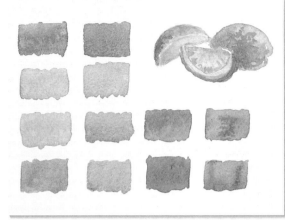

Experimenting with primaries

Equal amounts of yellow and red mix to give a strong orange, but invariably a deeper or a brighter orange is needed for a painting. Combining different proportions of the two primaries will produce a range of oranges. The colors above have been mixed on a palette, but layered washes of each primary will slightly vary the strength and luminosity of each orange hue.

Mixing a range of oranges

Use a range of primary colors to discover the best pigment mixes for different hues and strengths of orange. Experimenting with primaries in this way often produces exciting and surprising results.

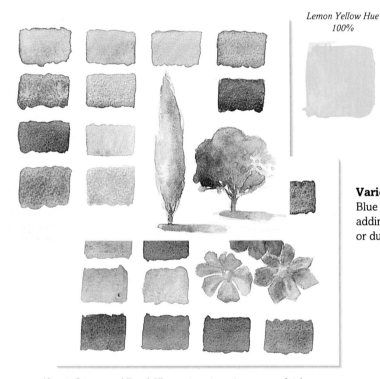

Lemon Yellow Hue
100%

75% Yellow
25% Blue

50% Yellow
50% Blue

75% Blue
25% Yellow

Winsor Blue
100%

Varieties of green

Blue pigments are powerful, so a green should always be mixed by adding small touches of blue to yellow. Greens can appear bright or dull according to the quantity of each primary *(left)*.

Alizarin Crimson and French Ultramarine mix to give a range of violets.

100%
BLACK

50%

100%
WHITE

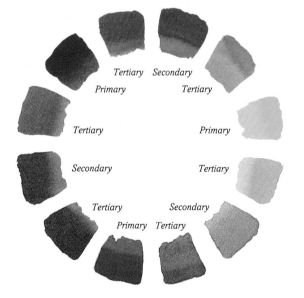

Tertiary *Secondary*
Primary *Tertiary*

Tertiary *Primary*

Secondary *Tertiary*

Tertiary *Secondary*
Primary *Tertiary*

The tone of color

A scale of tone helps determine the tonal value of an area of color. This tone bar appears with a color wheel on every project to identify the colors used and the tone they are painted in.

The position of colors

The color wheel is organized so that every secondary color lies opposite the third unmixed primary. When secondaries are mixed with their neighboring primaries, they produce "tertiary" colors.

GALLERY OF LIMITED COLOR

THESE GALLERIES combine historical with contemporary paintings to show how artists have used color. The English artists Gwen John and J.M.W. Turner relied on a limited range of pigments to show the power of color. John used a minimal range of browns with perfectly controlled tonality, while Turner's range of seven spectral colors created a subtly atmospheric work.

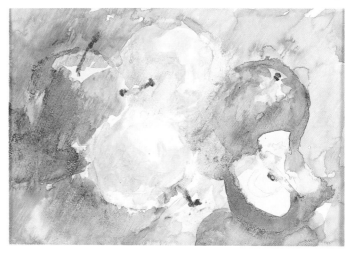

Gabriella Baldwin-Purry, *Apples*
The use of primaries in this work shows how a full spectrum of color can be achieved by mixing and layering three pigments. Translucent washes react with white paper to give strong tints and dark shades of color.

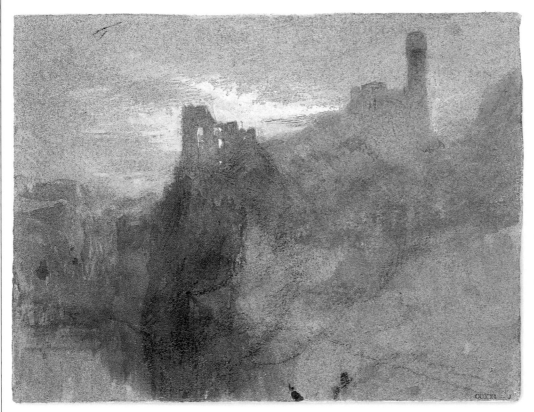

J.M.W. Turner RA, *Sunset Over a Ruined Castle on a Cliff, c.1835-39*
Turner was a visionary painter, with an outstanding mastery of watercolor. He used the medium to explore the expressive properties of color and light. This sketch on blue-toned paper is striking in that it reveals the complete spectrum of light: each of the seven colors has been painted onto the paper in order, separately and unmixed. Such straightforward color placing creates a stunning and evocative sunset. This work also records Turner's fascination for experimenting with his media. He painted with gouache to create an opaque appearance; he used the blue-toned paper to heighten the brilliance and intensity of the gouache. The same effect could be achieved by building many layers of translucent, pure washes.

Pure color based on the spectrum of light creates an extraordinary intensity of color in this painted sketch.

Turner concentrated more on depicting light, space, and color than on describing detail. This sketch is simple, yet powerful.

The bands of individual color develop into an expressive atmosphere of diffused light and shade, to give a powerful sensation of nature.

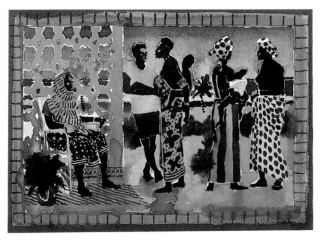

Gregory Alexander,
***African Variation,* 1984**

Alexander incorporated mixed media into this painting, using designers' procion (dye) to give a powerful strength of color and luminosity. Each wash is painted as a simple, flat block of color, but the pigments are saturated and pure, so that the washes glow brilliantly. While the flat washes force the composition into a two-dimensional design, the vivid hues, heightened by a deep matt black, make the figures radiate with light.

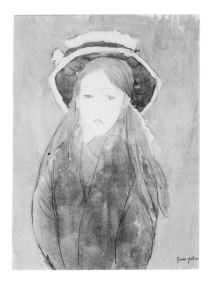

Gwen John, *Little Girl in a Large Hat,* **c.1900**

John's work was often modest in size, sober in mood, and muted in color, yet her paintings are powerful and tonally perfect. John laid colors on her palette systematically, to create subtle changes in hue and tone. This study is painted with a limited range of color, but the white paper that shows through in the face contrasts with the flat, soft brown washes, to create a subtle tension and stress the fragility of the child.

The limited range of pigments are painted as simple, flat blocks of saturated color.

Touches of white paper are left free to heighten the power of the intense exotic colors.

Human figures, painted with a flat wash of black paint, make a striking impact against the bright colors.

Edvard Munch, *The Kneeling Nude,* **1921**

Themes of death and sexual anxiety predominate in many of Munch's early works. However, later in his artistic career, having recovered from a nervous breakdown, he produced some highly poetic works. Watercolor provided Munch with a direct means of setting down his feelings visually, and of experimenting with the emotional impact of color. This painting is composed of expressive rather than naturalistic color. Simple strokes of deep, serene blue and warm brown create a remarkable sensation of form and shape.

Translucent washes of deep blue and rich brown pigment have been painted using loose expressionistic and lyrical brushstrokes.

Freehand brush drawing and areas of untouched paper combine with the tranquil hues to give a sense of great artistic calm and control.

WARM AND COOL COLOR

ANY PIGMENT has a natural bias toward either warm or cool sensations (*see* p.11). It is important to understand how this quality can affect color mixing and to know which pigments will give the cleanest and brightest secondary and tertiary colors. Primary colors that are divided into warm and cool produce the best results.

These warm and cool colors can also be used as opposites in painting to create light, depth, and space; warm hues appear to advance on the paper, while cooler hues seem to recede. Such colors "complement" or react to one another, and lie opposite each other on the color wheel, such as primary red and secondary green.

Cadmium Red (warm)

Cadmium Yellow (warm)

Alizarin Crimson (cool)

French Ultramarine (warm)

Lemon Yellow Hue (cool)

Winsor Blue (cool)

Color bias
These sets of primaries are positioned in a color wheel to illustrate the natural tendency of each color to lean toward another. Cadmium Red veers toward yellow, and Cadmium Yellow has a red bias. French Ultramarine also has a red bias, while Alizarin Crimson tends toward blue. Lemon Yellow Hue veers toward blue, and Winsor Blue to yellow.

Warm and cool color
It is worth exploiting the tendency of warm and cool primaries to lean in one direction. Primaries that are positioned closest together on this wheel create intense secondary colors, while primaries farthest apart produce neutral, or even muddy, colors (*see below*). With this range of six colors, any combination of warm or cool, strong, or muted color is possible.

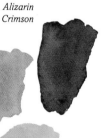

Cadmium Red

Alizarin Crimson

Alizarin Crimson

Cadmium Red

Bright, intense colors
A warm mix of yellow and red gives a strong orange, a cool mix of yellow and blue produces a vivid green, and a warm blue and a cool red give a deep violet.

Dull, muted colors
These primary combinations are not so effective and give muddier colors than may be wanted. Certain muted hues are more effective than others (*see* pp. 36-37).

Cadmium Yellow

French Ultramarine

Lemon Yellow Hue

Winsor Blue

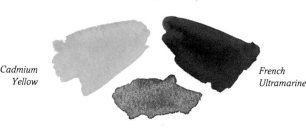

Lemon Yellow Hue

Winsor Blue

Cadmium Yellow

French Ultramarine

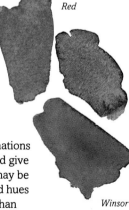

Traditional use of warm and cool color

There are three basic sets of complementaries; red and green, yellow and violet, and blue and orange. If you look at a lemon, you may notice that its shadow is a faint shade of violet. If this opposition is exaggerated in painting, the strong reaction created by complementary hues can give a convincing sense of space and light.

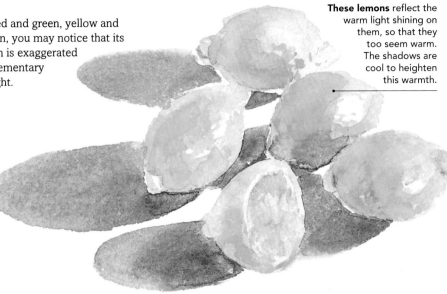

These lemons reflect the warm light shining on them, so that they too seem warm. The shadows are cool to heighten this warmth.

Warm highlights

An object painted with warm color appears to advance on the paper. These lemons are modeled with tints and shades of Cadmium Yellow. Where a sense of depth is required, a touch of cool violet pushes the underside of the lemon into recession.

Cool shadows

Painting cool shadows both heightens the warmth of an object and gives a sense of space and depth. The cool mix of Alizarin Crimson and Cobalt Blue makes the shadow appear to recede.

The lemons here are tinted by a cool light, so their appearance also becomes cooler. Shadows are warmer to give a strong contrast.

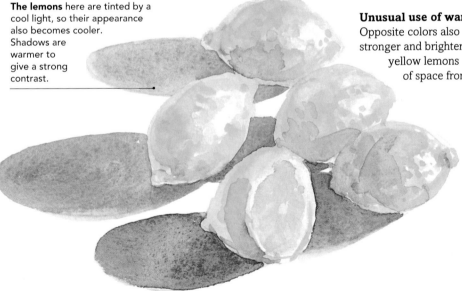

Unusual use of warm and cool color

Opposite colors also enhance each other, so that they appear stronger and brighter together than apart. This composition of cool yellow lemons and warm violet shadows still conveys a sense of space from the reaction of complementaries.

Cool highlights

These cool lemons have been painted with tones of Lemon Yellow Hue. The strongest highlights are created by unpainted paper, and the darkest areas have a faint wash of violet over the yellow.

Warm shadows

The lemons are painted with a cool primary pigment, so the shadows should be a warm violet. French Ultramarine and Alizarin Crimson mix to give a brighter, lighter violet wash to these shadows.

COMPLEMENTARY COLOR

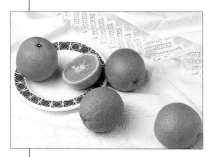

Arrange a simple but interesting composition.

THE COMPLEMENTARY COLORS of red-orange and blue react together so strongly in this painting that they enhance each other and become more powerful together than apart. The strong artificial lighting illuminating each orange produces dark, well-defined shadows that appear cool and blue. Luminous yellow highlights on the oranges are also contrasted by subtle violet washes in the blue shadows. These sets of saturated complementary colors together create a vibrating tension that gives the painting a dramatic sensation of light and space.

1 ◀ Draw the outlines of the oranges using a large brush, such as a No.10, with a light wash of Cadmium Yellow. Once the composition is loosely sketched, build up the form of each fruit with a strong wash of Cadmium Yellow. Use curved brushstrokes to model the general shape of each orange.

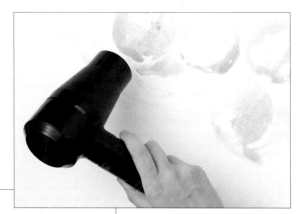

2 ▲ Leave the lightest tints to dry, so that they will not be obscured by additional washes. Although much of this picture is painted with a wet-in-wet technique, a hair-dryer is useful to prevent intermixing between washes and to check on the strength of a dried wash.

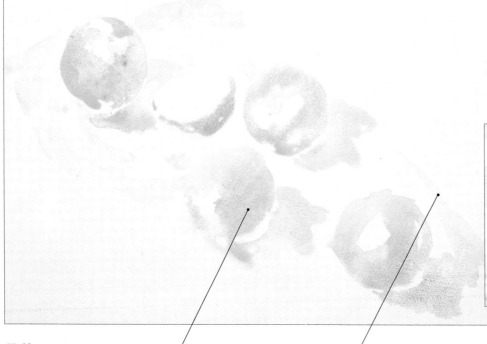

3 ▲ Mix a rich, vibrant orange from Cadmium Red and Cadmium Yellow. Mixed in different quantities, these hues provide a range of tints and shades. Use saturated washes to create shape and depth around the edge of the fruit.

Halfway stage
The violet-blue shadows that complement the fruit are cool enough to recede, yet strong enough to enhance the orange washes.

The paper is primed with acrylic Gesso primer to give the washes a mottled effect. It also prevents washes from being absorbed into the paper so that they float freely.

The white cloth both absorbs and reflects color from the oranges and their shadows. Lemon Yellow Hue gives highlights, and Cobalt Blue and Winsor Violet shadows.

5 ▲ Work around the painting, developing the objects and their shadows at the same time. Use a wash of Cobalt Blue and Winsor Violet to paint the shadows of the cloth. Paint a simplified pattern on the plate rim with a small brush, such as a No.5.

4 ▲ If you keep the washes wet enough, mistakes can be lifted out with a sponge. If the paint has dried, use a clean wet brush to soak the wash again. A painted wash may look too strong, so load a brush with clean water and dilute the pigment on the paper, or dab gently with a sponge for soft lights.

6 ◀ Overlay the blue shadows with washes of Cobalt Blue, Winsor Violet, and French Ultramarine to build up the right intensity of shade and depth. Use the same wash and a small brush for the lace holes at the edge of the cloth. Paint other fine details such as orange stalks with this brush.

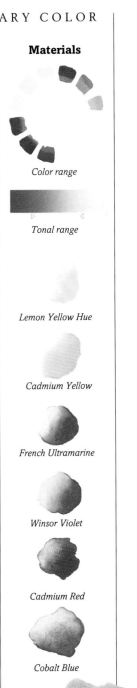

Materials

Color range

Tonal range

Lemon Yellow Hue

Cadmium Yellow

French Ultramarine

Winsor Violet

Cadmium Red

Cobalt Blue

Sponge

No.4 sable brush

No.5 sable brush

No.10 synthetic/sable mix brush

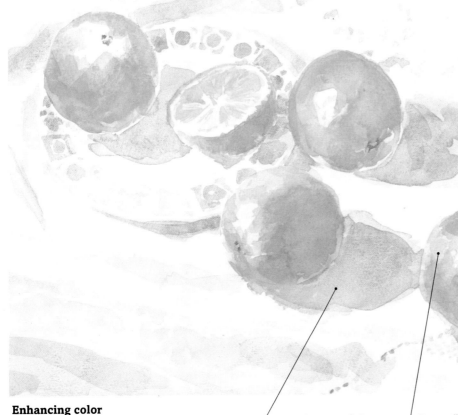

Enhancing color
Layers of complementary color contrast and enhance each other. Vibrating tints of orange advance on the page, while passive cool blue shadows recede into the background.

A wet-in-wet technique and spontaneous mixes of pure, saturated color capture the looseness and fluidity of watercolor.

Pure yellow highlights on the lightest areas of the oranges are subtly complemented by violet in the blue washes.

GALLERY OF COMPLEMENTARIES

MANY ARTISTS produce strong paintings by using the dramatic powers of complementary colors. The colors used by the French artist Paul Cézanne created a solid foundation for his stunning portrayal of light and form, while the German Emil Nolde relied on vibrant color combinations to create dramatic expression. This varied collection demonstrates the range of effects possible using complementaries.

Deep shades of blue cut across the angled profile of the man, casting him into obscure shadow.

Dramatic complementary washes of orange throw the face of the woman into uneasy relief.

Emil Nolde (attr.), _Man and Woman_, c.1939-45
Nolde used stunning complementary color for this painting. He had a forceful, dynamic ability with color, appealing to the senses rather than to the mind. Nolde used color in order to describe the tension that he felt was prevalent in all human relationships. Dark shades of pure color cast the man into obscurity. The lifeless stance of the woman is accentuated by flat orange and pink washes, but her pulsating cold blue eye in the midst of the orange adds to the uneasy strain inherent in the painting.

Gisela Van Oepen, _Cadbury Hill_
The images Van Oepen paints in her landscapes are refined and pared of detail, and her complementary colors are dramatically pure and strong to create a brilliant reaction together.

Cooler blues recede into the horizon, while vivid startling hues of orange and red jump into the foreground, creating contrast and depth.

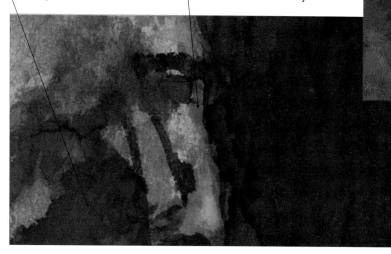

A thick stroke of French Ultramarine enlivens the orange wash, while the faint traces of weak yellow subtly complement the violet–blue skies.

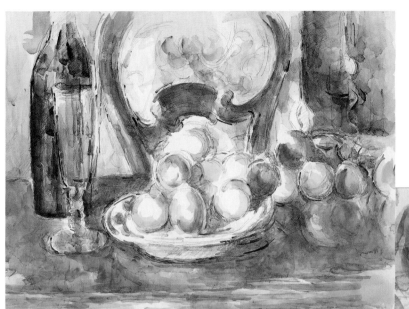

Paul Cézanne, *Still Life With Apples*, 1900-06
Cézanne was obsessed with light and color. He saw that light defined the outline and form of an object, and he used complementary color to recreate the effect of that light. Circular strokes of thin gouache suggest apple shapes, and the remaining off-white paper is left exposed to create space and light. Saturated violet-blue shadows react with the dull yellow, and the brushstrokes of intense bright green on the right offset the deep, warm red of the table. Subtle echoes of these colors in the background increase the lyricism and continuity of the painting.

Dante Rossetti, *Horatio Discovering Ophelia's Madness*, c.1850
A Pre-Raphaelite, Rossetti was inspired by medieval art and legends, and his works are full of decorative richness and strong color. Complementary reds and greens show fine details, while the blue dress at the center irradiates against a golden yellow background.

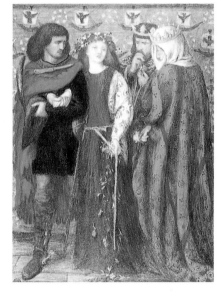

Cézanne used colors that encompass the spectrum of light, painting not the local color of objects, but their reflected light.

Complementary colors are painted as strong and weak washes to model and define objects and surfaces.

Christopher Banahan, *Roman Basilica*
Banahan's limited palette of pigments shows that simple contrasts of complementaries can look powerful in his paintings. Banahan works quickly and spontaneously with loose brushstrokes, letting the few colors he uses describe the main structures and shapes of a scene. Banahan does not allow more than one color to dominate a painting, so the saturated block of orange in the foreground becomes a focal point of the composition and is complemented by a large expanse of pale blue sky. This intense, dramatic shade of orange combines with quieter areas of muted color to give a sense of depth. The warm yellow of the dome and columns is heightened by lower shades of complementary violet.

COLOR INFLUENCE

IF TWO COLORS are placed side by side, they have an immediate effect on one another, accentuating any differences or similarities and heightening the degree of saturation of each hue. Complementary colors exemplify this concept, enhancing and strengthening one another, if viewed simultaneously. This interaction, or color influence, adds visual tension to a painting and allows each color to achieve its optimum potential. Certain colors create a dynamic brilliance together, while other hues detract from one another.

Light colors within dark surroundings
If the eye perceives two adjacent hues, it automatically makes modifications that alter the intensity of each hue. A dark hue surrounding a light color looks denser and heavier, while the light color looks brighter and larger than it actually is.

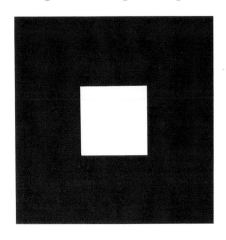

Dark colors within light surroundings
A larger area of light color that surrounds a dark hue appears bigger and less dense than if an identical area of the same light hue were uncontrasted. Although the same size as the small white square, this dark square appears more intense and smaller.

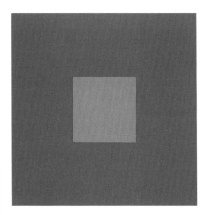

An area of light orange on a dark blue square looks brighter and more saturated than on its own.

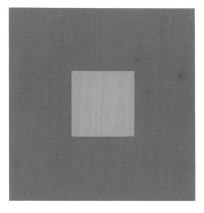

A green square on a red background appears lighter, while the red seems to darken.

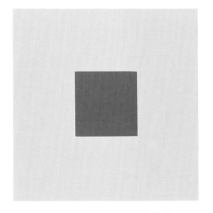

The large area of light yellow looks less bright, while the intense purple vibrates.

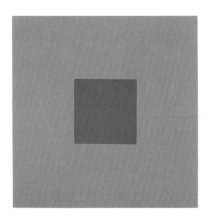

A small dark blue square on a light orange background appears more vibrant.

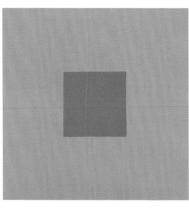

The large area of green appears duller and darker, while the red gains in light and intensity.

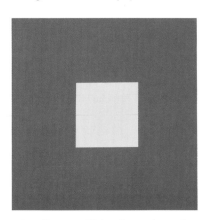

A small amount of light yellow on the purple square appears to have an intensely bright quality.

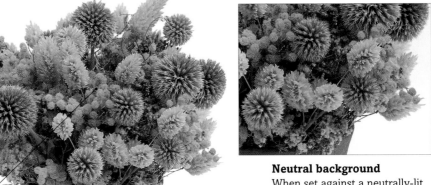

How colors affect each other

It is important to understand the influence that colors have on each other. Some hues create discordant effects with certain colors, while others actually enhance them. The basic principle of complementary color is a good basis for determining effective contrasts. These dried flowers are full of muted, understated hues (*see* pp.36-37), but they can change appearance rapidly when set against a range of different colored backgrounds.

The dried flowers are a mixture of dark yellows and light ochres.

The terracotta pot appears a deep, rusty red under natural light.

Neutral background

When set against a neutrally-lit background of white light, the colors of this still life retain a "natural" appearance.

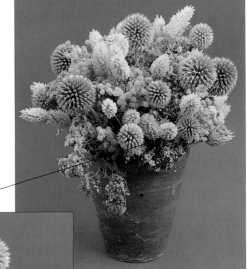

The warm yellow color of the background only serves to emphasize the lack of pure color in the still life.

The contrast created by the deep blue accentuates the muted hues, so that they seem brighter and purer.

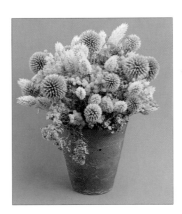

Color that detracts

Positioned in front of a strong yellow background, the colors of the still life all appear dull and unattractive. They lose saturation and appear darker against the strong backdrop.

Color that enhances

When the still life is placed before a deep blue background, its hues are instantly enhanced. The orange or yellow accents in each flower are heightened, so that they glow brilliantly.

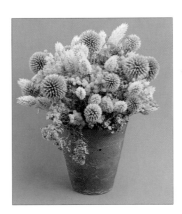

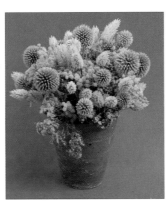

Set against a strong red backdrop, certain areas of the still life become lost, dissolving into the background.

Against a light blue color, the muted colors vibrate powerfully. The cool blue heightens the warmth of each hue.

This magenta influences the yellow hints in the flowers, so that they appear purer, but loses the definition of the pot.

The green background influences the orange and red qualities of the still life, so that they radiate strong, bright hues.

EXPLORING COMPOSITION

Composition is built up of elements that include shape, value, and color.

THE LIMITED RANGE OF COLORS in these paintings illustrates a useful way of exploring the potential of the same color scheme in four very different pictures. The variety of results from this small range shows how the placing of colors can significantly alter the success of a composition. Color combines with vital elements such as shape and tonal value in these quick paintings to create an overall balance of composition. All the paintings have a natural unity through the recurrence of the same colors, but a different sensation and effect have been produced in each work. Color is also used in this instance to evoke a mood rather than describe a subject.

1 ▲ Paint a flat wash of French Ultramarine on a large sheet of cold-pressed NOT paper with a large brush. Cover the surface of the paper with a very light tint of the same wash, and then feed in washes of Ivory Black and Sap Green.

2 ▲ Add an intense wash of turquoise, and randomly sketch the form of a tree to complete the composition. The color should instantly bleed and blend into the wet paper. Composition and color are more important to consider than are details or objects.

3 ▲ In this painting, the arrangement of colors is reversed. Paint a strong wash of Ivory Black over the sky and the background and a saturated wash of French Ultramarine in the foreground.

4 ▲ Add an intense stroke of Sap Green to the left of the composition to offset the cool blue and black washes. These strong hues give a powerful visual effect.

5 ▲ Apply dabs of very saturated, dense French Ultramarine to add a deeper tone to the painting and to break up and balance the large expanses of flat color in the composition. This picture relies on more intense shades of color than do the other images.

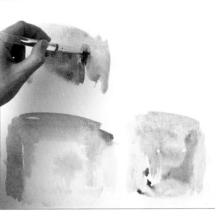

6 ▲ Paint the sky and background of the third painting with a dominant wash of Sap Green. Add blocks of strong Turquoise and French Ultramarine to the wet green wash, and let the colors blend, to produce more subtle secondary hues and to create accidental shapes and forms.

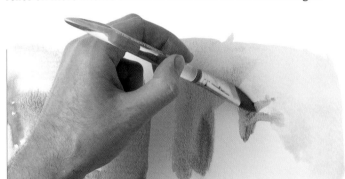

7 ▲ Use contrasting colors for the final work, to evoke a stronger mood. Paint a wash of Cadmium Red over the background and complement it with a rich wash of Sap Green in the shape of a tree.

8 ▲ Add a vivid stroke of Cadmium Red to balance the intense green, and work the red wash around the outline of the tree. Add subtle tints of Raw Umber to the base.

Exploring Composition
A limited palette of colors, combined with a variety of shapes and tones, produces four very different paintings. The mood of each painting depends on the intensity and relationship of colors.

The wet-in-wet technique allows washes to mix and edges to soften to create lucid, balanced compositions.

This painting has the most successful combination of color, shape and tone, creating a subtle mood.

Materials

Color range

Tonal range

French Ultramarine

Sap Green

Cadmium Red

Ivory Black

Raw Umber

Turquoise

½ in synthetic brush

1 in synthetic brush

HARMONIOUS COLOR

To PAINT HARMONIOUSLY is to compose with color to position a group of colors in an aesthetic arrangement. There are no fixed rules about harmony, but there are important guidelines that govern the relationship between colors. Harmony is determined by the order and proportion of colors: the simplest harmony, produced by mixing two hues and placing the resultant hue between them, creates a common bond that unifies the initial hues. Harmony occurs if hues have the same tonal value or saturation, or a dominant color unites a range of tints and shades. Hues next to each other on the color wheel create "adjacent harmony." Correctly proportioned complementaries create "contrasting harmony."

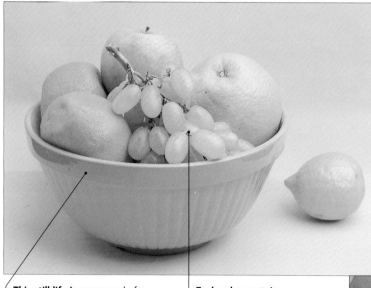

Dominant tints
A harmony occurs if colors have a correspondence, a linking quality that unifies a composition. The different objects in this still life are linked through their association with the dominant primary color, yellow.

This still life is composed of a range of differently colored objects that can all be linked to one primary color.

Each color contains a certain quantity of yellow. The many hues include secondaries and tertiaries.

Adjacent harmony
The unity that the dominant yellow hue creates in this still life is known as adjacent harmony, which is based on colors that lie near or next to each other on the color wheel. Adjacent harmony can be based around any one of the three primary colors.

Adjacent yellows
Adjacent yellows range from light green to yellow and orange.

Adjacent reds
These range from dark orange to violet. Tertiaries lie at either side of the primary.

Adjacent blues
These cover cool violets through to deep greens. The secondaries lie at either end.

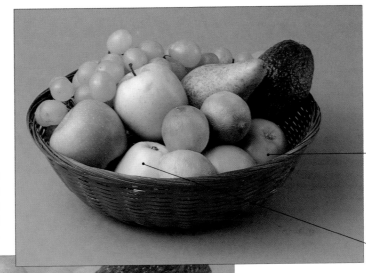

Monochromatic harmony

Pure Viridian Green (*left*) has been lightened into a tint and then mixed (in order) with yellow, blue, red, and finally black, to create a range of greens. The presence of green in each mix gives harmony.

Unifying color

The wide range of tones in this still life harmonize because of the dominant green hue in each object.

The local color of each object in the bowl may differ in range from a dark green to a light yellow green. The quality of light and saturated color in the background heighten the green appearance of each piece of fruit.

These objects produce a strong harmony because they have far more in common than in discord.

Subtle harmony

The pervading green that persists in this range of tones creates a subtle sensation. The degree of visual change between each colored object is minimal.

Contrasting harmony

Red and green are equal in intensity and light, so they should occupy equally proportioned areas of a painting.

Two-thirds blue and one-third orange together give the correct balance, as orange is more vibrant and intense.

Yellow should only occupy one-fourth of an area that includes violet, or the strength of the violet will diminish.

HEIGHTENING A COMPOSITION

Correctly proportioned complementary colors will harmonize, but if these complementaries are painted in unequal proportions, a different look can be created that heightens the visual impact of a painting. The strong touches of red within this green still life generate an exciting vibrancy (*see* pp.22-23).

A small area of red, surrounded by a large area of green, accentuates the visual impact of the still life.

The opportunity for a small amount of red to shine against the complementary green of this fruit means that it becomes increasingly vivid and concentrated.

The sets of complementary colors above are divided theoretically into proportional areas to illustrate the ideal balance of opposite hues. Yellow occupies less space than violet as it has a higher tinting strength and so is more powerful. These proportions depend on the maximum saturation of each hue. If their intensity and value alters, so do their proportions.

GALLERY OF COMPOSITION

EVERY PAINTING relies on elements such as color, tone, and form to create a successful composition. The German artists August Macke and Emil Nolde were masterly in the way they achieved stunning effects with bold, spontaneous hues, while the tones and subtle hues painted by the American Winslow Homer give a strong sense of depth.

August Macke, *Woman with a Yellow Jacket*, 1913
Macke had a fine sense of proportion, structure, and tone. The related shapes and colors in this arrangement create a unique visual impact. Macke placed his adjacent hues carefully to make one pigment irradiate beside another. The light yellow tint of a woman's jacket next to the dark saturated blue shadow of a man appears to brighten and advance. A small white gap left between the two pigments allows each to retain its own strength of color. Dark, shaded greens complement repeating vivid red and orange shapes. The eye is led around the picture by figures that move toward and away from the light and by two lines of perspective that control the movement at the right. A range of light and dark tones allows the eye to jump randomly from one rich area of color to another.

Repeating shapes and colors balance and complement each other to create a carefully structured composition.

Macke pitched the strengths of these pure hues perfectly, so that they enhance one another with a powerful radiance.

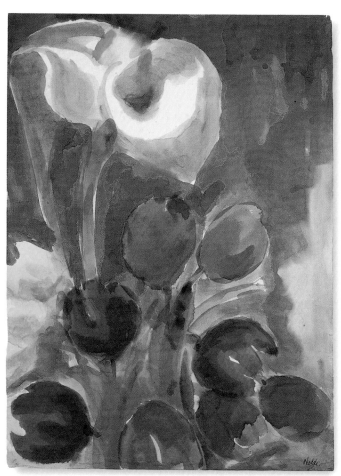

Emil Nolde, *Arums and Tulips*, c.1906
Color was the greatest means of expression for Nolde. His washes flow spontaneously into rhythmic, beautiful forms, so that color becomes the life and vitality of a painting. Nolde painted flowers because they are so temporary, bursting into bloom with rich, glowing color, only to wither and die. Just a small amount of saturated color on these red and yellow tulips makes them sing against the blue background. Their bright tints lift right out, without overpowering the quieter shades of green and the dark violet tulips that bend back. The two small strokes of orange stamen that control the mass of blue demonstrate Nolde's innate ability with color.

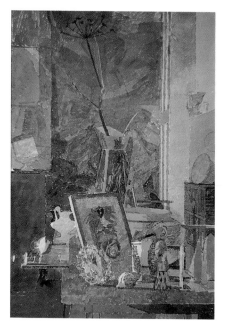

Paul Newland, *Interior*
Newland's aim is to build a coherent system of tones and colors into each painting to create a subtle composition. He works with a range of muted colors that give a warm glow and also imply depth. Each object exists in its own space and is gently modeled with toned color to give it form and substance. Softly illuminated objects on the table contrast with abstracted shapes and objects against the wall.

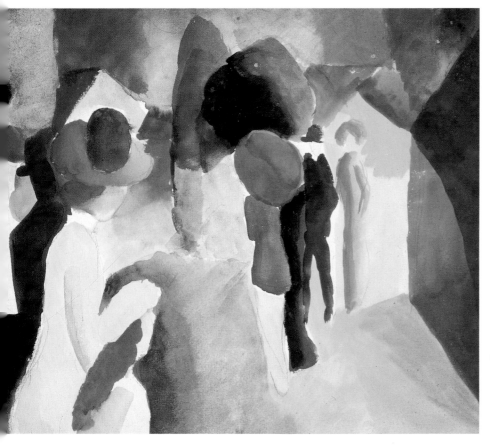

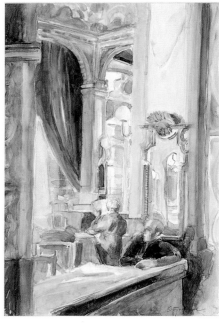

Sharon Finmark, *Café 2*

The space and light in this interior scene have been achieved with a combination of different tones and colors. The diagonal plane of intense yellow leading the eye up into the picture is strengthened by the cool violet and gray forms around it. A vertical block of light yellow holds the attention right up through the center of the painting and beyond. Light floods down from this area, warming the heavy rich reds and gilded orange hues. Small touches of pale cool green and violet shadows gently offset the large washes of red and yellow.

Homer captures the effects of outdoor light with a subtle range of tonal colors.

Controlled shapes and planes of color lead the eye around the painting.

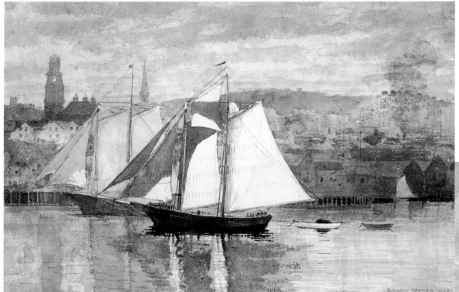

Winslow Homer, *Gloucester Schooners and Sloop,* **1880**

These muted tonal colors are painted with fluid brushstrokes so that they produce a beautiful watery effect. Homer overlapped several transparent washes of luminous color to work up the right tones. He also defined the negative shapes between objects as much as the objects themselves, to emphasize the shape and depth of the picture. This is shown clearly by the shaded areas of sail on the main schooner. The paper becomes the white body of the sail, with the dark shadows painted as negative shapes on top. The strong white tint of the sail, balanced by the dark tones of the wooden hull, becomes a focal point of this composition, drawing attention to the extremes of tone in this subtle work. Homer often reworked his pictures using subtractive techniques such as rewetting and lifting paint layers. He also softened the edges of shapes with a brush, to create more subtle effects and visual sensations.

29

HIGH-KEY COLOR

HIGH-KEY PAINTINGS are built up of bright, saturated colors that evoke a feeling of strong light. The sharper the light in a setting, the more pure and dramatic colors appear. Clear, bright morning light will enhance the saturation of hues, while intense afternoon light can bleach out their strength. The color that we perceive is actually light reflected from surfaces in a setting. If the quality or strength of light changes at all, so do the colors of objects and the nature of the light being reflected. This change can create a completely different sensation. Lively, vibrant light can be created with a combination of techniques.

Bright morning light
This sketch captures the clarity of morning light shining on to a group of city buildings. Complementaries enhance one another to create a brighter reaction, so that light seems to gleam from the smooth surfaces of the buildings. Each color is at its most saturated and luminous to convey the quality of clear, radiant light.

Violet

Yellow

Flat, luminous color
High-key paintings can be built up of flat washes of saturated color. Placed side by side, the blocks of strong, pure orange and blue, and yellow and violet, influence one another to create a sensation of clear, powerful light striking the buildings.

Blue

Orange

Broken Color
Areas of broken color, created by painting individual strokes of saturated pigment beside one another, retain their maximum vibrancy while also appearing to blend. (This blending is known as optical mixing, *see* p.31.)

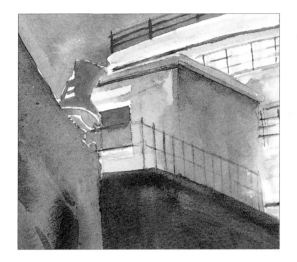

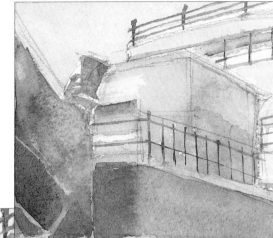

Hazy afternoon light
As the light changes, the dramatic, brilliant colors of the morning *(left)* are bleached out by a more intense light that makes this scene appear much paler *(right)*. Pigments are mixed with a larger quantity of water to create bright tints that give a sensation of hazy, high-key light.

Blue

Violet

Yellow

Creating different light effects
A small amount of water mixed with a pigment gives an intense, luminous, saturated wash *(top)*. As more water is added, the wash becomes paler and loses its intensity *(bottom)*, but it keeps its luminosity, retaining a sense of bright light.

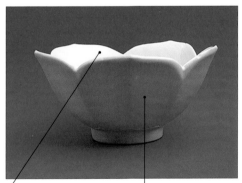

Hazy effects
There are fewer dramatic contrasts in tone with the pale tones of hazy light *(left)*, so the flat washes of color blend softly into one another with a wet-in-wet method. In the areas where washes are layered, or painted as broken dabs of color, a third color can be perceived in the effect known as optical color mixing.

REFLECTED LIGHT

The perceived color of any object is actually influenced by the nature of colored light reflected back off the local hue of that object – whether a simple object or a complex cityscape.

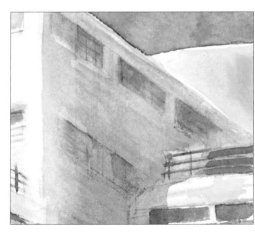

Reflections in a landscape
Sometimes surface reflections mingle together to create a new color. Where the bright yellow reflections of this building are reflected back into the violet shadows, the colors mix into a third deep, muted hue.

The bowl changes color according to the color of light hitting its surface.

Blue light creates tints and shades on the bowl's surfaces.

The appearance of objects
White objects reflect most of the light shining on them, and this white bowl provides an effective illustration of the nature of reflected light. The bowl reflects the surrounding blue light and thus appears to be blue itself. Where white light shines on the object from above, it reflects back that light and looks white. Mixing pigments together is equivalent to the sensations of light reflecting off objects and surfaces.

Under a green light, the bowl appears cool.

The bowl appears deep and rich under a red light.

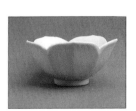

Orange light makes the object appear light and warm.

HIGH-KEY STILL LIFE

THIS HIGH-KEY PAINTING is built up of a limited range of pure, saturated pigments, to create a sensation of intense light. The complementary colors of blue and orange and red and green have a powerful effect on one another and vibrate together, to create a visual tension of bold, pulsating color. This sense of high-key atmosphere is created by flat washes of translucent pigment, occasionally enlivened by small individual strokes of rich color.

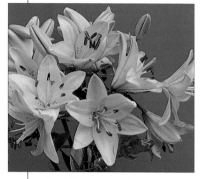

These flowers sing so brightly because of the intensity of the blue background.

1 ▷ Sketch the composition lightly on NOT paper. Mix a strong wash of French Ultramarine and apply it with a medium brush, such as a No.9, across the background. Use fast, loose brushstrokes to paint around each flower, filling in the areas between flowers and stems to create interesting negative shapes. The heavy blue wash may appear granulated as it settles into the dips and hollows of the paper.

2 ▲ Overlay the background with another flat wash of French Ultramarine, if the first layer does not appear strong enough. Though this is a more unusual way of building up a composition, the reaction of the paler-colored orange flowers depends on the intensity of the blue background.

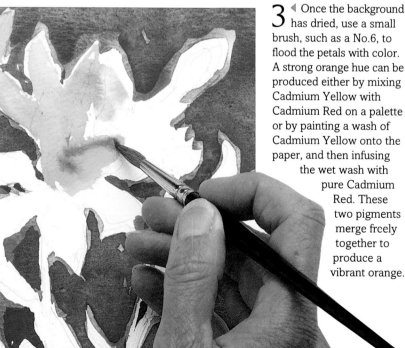

3 ◁ Once the background has dried, use a small brush, such as a No.6, to flood the petals with color. A strong orange hue can be produced either by mixing Cadmium Yellow with Cadmium Red on a palette or by painting a wash of Cadmium Yellow onto the paper, and then infusing the wet wash with pure Cadmium Red. These two pigments merge freely together to produce a vibrant orange.

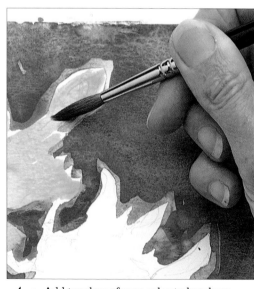

4 ▲ Add touches of new color to break up the washes of orange and blue. Mix Winsor Blue and Lemon Yellow Hue to give a secondary lime green for the unopened buds. This subtle hue should not overpower the two complementaries.

5 ▷ Build up the stems of the flowers with the same lime green wash. Paint right beside the strong background wash of French Ultramarine, overlapping the washes if necessary, to cut out any sight of white paper beneath. The absence of white in the composition should allow colors placed side by side to influence one another, to create the strongest reaction possible (*see* pp. 22-23).

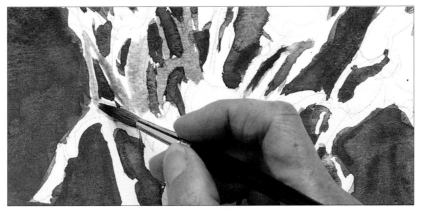

Materials

Color range

Tonal range

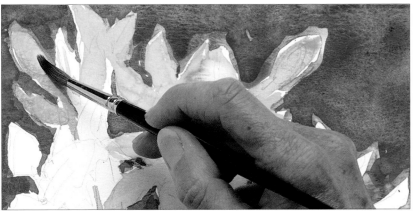

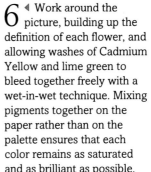

6 ◁ Work around the picture, building up the definition of each flower, and allowing washes of Cadmium Yellow and lime green to bleed together freely with a wet-in-wet technique. Mixing pigments together on the paper rather than on the palette ensures that each color remains as saturated and as brilliant as possible.

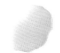

Cadmium Yellow

Lemon Yellow Hue

Cadmium Red

Winsor Blue

French Ultramarine

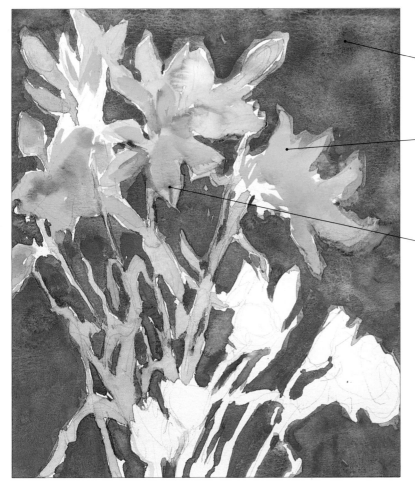

Heavier pigments, such as French Ultramarine, may settle into the hollows of the paper and appear mottled.

The purity and translucence of each pigment allows light to reflect off the paper and illuminate the whole painting.

Colors that bleed together freely with a wet-in-wet technique retain their tinting strength most effectively.

No.6 sable brush

No.9 sable brush

Halfway stage

In this unusual composition, created by closing right in on the flowers for a cropped image, the principal complementaries of orange and blue create a powerful impact. The large area of deep blue background contrasts and enhances the lighter orange petals of the flowers, so they glow brilliantly.

7 ▶ Use a small brush to apply a wash of Cadmium Red for the red flowers. This strong color contrasts with the bright green stalks, so that the balance of the composition is built around two sets of complementaries. Only a small quantity of red pigment is needed to offset the areas of green pigment, as its tinting strength is very high. Push the color right to the edge of the flower so that it will pulsate beside the blue wash.

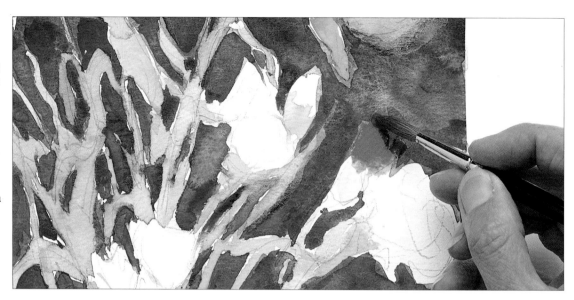

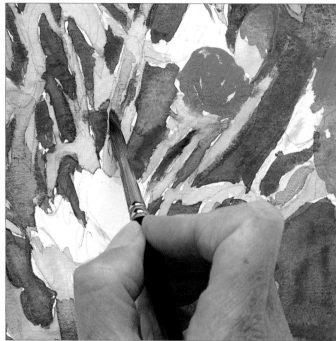

8 ◀ Mix a deeper wash of Lemon Yellow Hue and Winsor Blue, and lightly paint it down the edges of the stems and leaves with the small brush. The larger quantity of cool blue in this dark hue will push it into recession and enhance the predominance of yellow in the light green wash. This simple contrast in tone will give more form and interest to the stems.

9 ▲ With the small brush, fill any unpainted areas of the flowers with more pigment. Continue to mix pure washes of Cadmium Red and Cadmium Yellow on the paper, and then merge touches of the light green wash into these wet pigments to give the flowers a greater variety of subtle secondary hues.

10 ▲ As the washes on the petals are drying, add some quick brushstrokes of pure Cadmium Red to the center of each petal to shape and define it. The wetness of the orange wash should soften the edges of the red lines. These strokes of intense, broken color fragment the larger washes and enliven the painting.

11 ◀ When all the washes are dry, rework a strong wash of French Ultramarine around the flowers and stems to define their shape clearly. Work the color right to the edge of the lighter hues with the small brush. Any brushstrokes of blue that overlap the orange or red washes will create deeper hues of violet and green and will also produce interesting patterns.

12 ▲ Finish the painting with final details, such as the filaments. Mix Winsor Blue with a small amount of Lemon Yellow Hue to create a wash of green, and apply several lightly painted brushstrokes at the center of each flower. Mix a very dark wash of French Ultramarine and Cadmium Red for the anthers.

High-key Still Life

The composition of this still life is arranged so that every shape, form, and color is balanced effectively. Diagonal lines created by the flower stems lead the eye right up to the focal point of the painting. The purity of every vibrating color gives this painting a powerful luminosity. Small details, painted lightly at the center of each flower using a dry brush technique, create areas of broken color among the flat washes of the complementary colors and increase the lively atmosphere.

Pure, saturated colors have been optically mixed on the paper, rather than on a palette.

Small strokes and dabs of broken color emphasize the spontaneity and lightness of the composition.

The absence of white paper allows the complementary colors to influence one another. Each color is heightened by its opposite, so that its appearance seems to change.

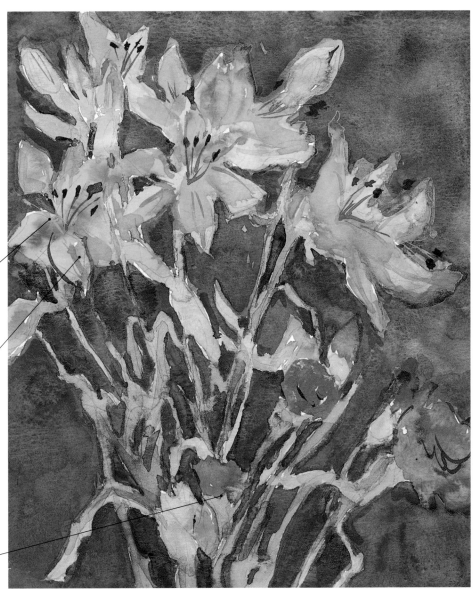

LOW-KEY COLOR

WHILE HIGH-KEY PAINTINGS rely on bright, saturated color for their vibrancy and impact, low-key paintings depend on unsaturated washes of color to create subtle atmosphere. A pure color can be unsaturated if it is tinted (by using the white of the paper) or mixed with another color. If a primary and its adjacent secondary are mixed, they create a tertiary hue (*see* color wheel on p.13). If, however, any three colors are mixed, they form a colored neutral that harmonizes and enhances purer washes.

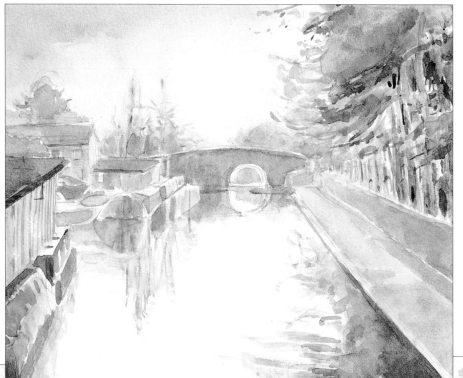

Unsaturated colors
Muted colors, such as the unsaturated hues above, are perfect for low-key atmospheric work. Their similarity in tone and strength creates harmony, and they enhance one another to appear more colorful.

Creating atmosphere
A subtle range of unsaturated hues describes this cool, misty winter's day. Pigments are mixed both on the palette and on the paper to create areas of gently glowing color. A final thin wash, or glaze, of Permanent Rose over the whole painting blends and unites any disparate elements.

Muted color
The deep shadows in this sketch have been built up with several layers of muted hues. Separate washes of pale color are applied individually to retain their luminosity and create gradual tonal changes. These soft, unobtrusive shadows that absorb the light create a quieter, more restrained mood.

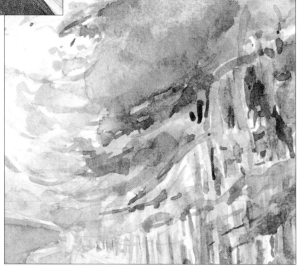

Mixing unsaturated hues
These hues are gradually deepened by incorporating a cool primary blue into the washes. If too many pigments are added, the wash will muddy and lose its luminosity.

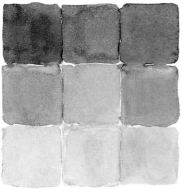

Blue and orange mixed in unequal amounts.

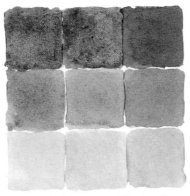

Green and red mix to give soft luminous hues.

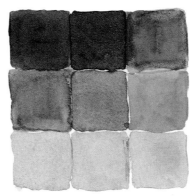

Violet and yellow create warm and cool hues.

Colored neutrals

A flat, uninteresting neutral gray can be produced by mixing all three primaries equally. However, these colored neutrals *(left)*, created by mixing two pigments in unequal amounts, can enrich a picture with their warm or cool luminosity.

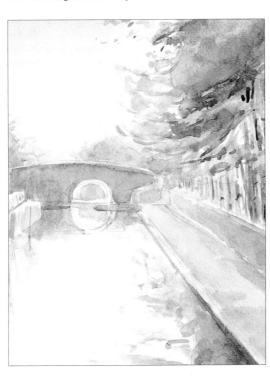

Toned paper

Toned paper *(right)* creates an underlying unity for a painting, harmonizing the hues with a dominant tint that influences the mood of a scene. The advantage of toned paper is that it performs like an extra wash, so less paint is needed.

Creating effect

The pigments here appear brighter and more luminous than those on the left, as fewer layers of paint are used to create the same effect. Although quite sketchy, it appears more finished than it would on white paper.

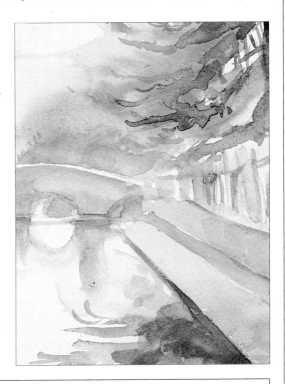

Soft, distant color

Fewer washes of muted pigment give a lighter mood. The washes are allowed to flow into one another, to produce more unsaturated colors.

LUMINOUS GRAYS

Luminous grays are vital to the gentle glow of low-key pictures. A primary or saturated color gains in brilliancy and purity by the proximity of gray. A wide range of grays can be created by mixing complementary pigments in a variety of unequal proportions. A luminous gray with a predominance of blue, for example, will heighten a wash of softly vibrant orange.

Winsor Blue and Cadmium Red give a warm luminous gray. If mixed equally, the complementaries cancel each other.

Cadmium Yellow and Winsor Violet mix to give a deep, rich gray.

Permanent Rose and Winsor Green create a cool luminous gray.

LOW-KEY INTERIOR

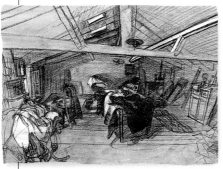

A tonal sketch defines lights and shadows.

THIS LOW-KEY INTERIOR is built up of soft, subtle hues that are restful to the eye, inducing a feeling of stillness and calm. The diffused evening light from the open door and window creates soft, deep shadows and fills the painting with a mellow atmosphere. Each object in the room has been gently molded with a variety of tones, so that they exist as separate images while still enveloped in the hazy light and remaining part of the composition. The shadowy areas of luminous gray enhance more delicate pure colors, so that they gain in brilliance and give the painting a glowing sensation of soft light.

Patterned fabrics provide an interesting feature.

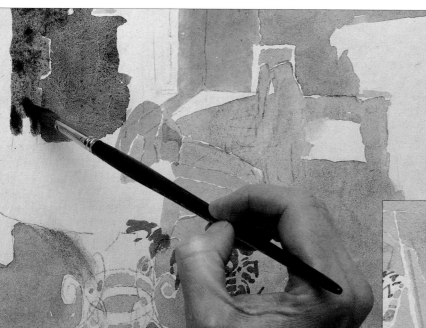

1 ◀ Lay the first washes of Yellow Ochre, Ivory Black, Terre Verte, and Burnt Umber down with a medium brush, such as a No.9. Paint them simply as blocks of adjacent color to develop the directional light and transparency of pigments in the painting. Stretched, unbleached rag paper acts as a tinted base for this painting and warms up the pigments slightly. The paper is also rough and absorbent, so that the pigments do not sit in pools across the paper, but sink in and blend instantly.

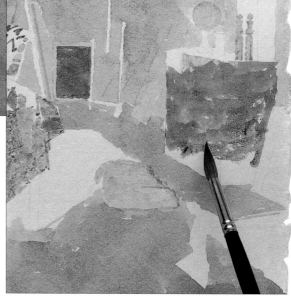

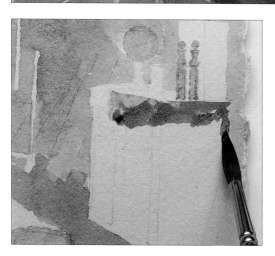

2 ◀ Develop the different areas of the room at the same time, so the painting is built up gradually. If you deliberate over one area for too long, the work may appear unbalanced. Objects at the right side of the room have the least light and the most shadow, so paint the chest with a deep wash of Indian Red and Vandyke Brown.

3 ▲ Apply the wash with short brushstrokes, taking the brush off the paper frequently to create gaps in the wash and prevent it from looking heavy and flat. The white of the paper shows through the pigments.

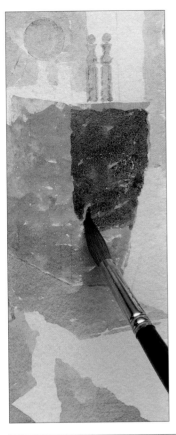

4 ◀ Paint the shadowed area of the chest with a dark wash of Vandyke Brown. Keep the paint translucent enough to allow the lighter wash to show through and add texture. This tone is built up simply, but the result is effective – the contrast of shades creates depth and structure. Paint the edges of the chest with soft lines to create a diffused light.

5 ▲ Paint a thin wash of Yellow Ochre, Indian Red, and Burnt Umber over the ceiling to give a warm glow of softened edges and colors. This brown-tinted glaze over the top half of the picture also blends and unites separate washes.

6 ◀ Take out mistakes or thin any strong washes with a damp sponge or paper towel. Try not to blot too much when you paint low-key pictures – otherwise the shapes will lack definition and give a "drizzly" effect. If you overlay too many washes, the pigments will mix into a muddy confusion. Avoid having to lift out such heavy color by restricting the number of washes you paint.

Materials

Color range

Tonal range

Burnt Umber

Indian Red

Vandyke Brown

Cobalt Blue

Ivory Black

Yellow Ochre

Hooker's Green

Terre Verte

No.7 sable brush

No.9 sable brush

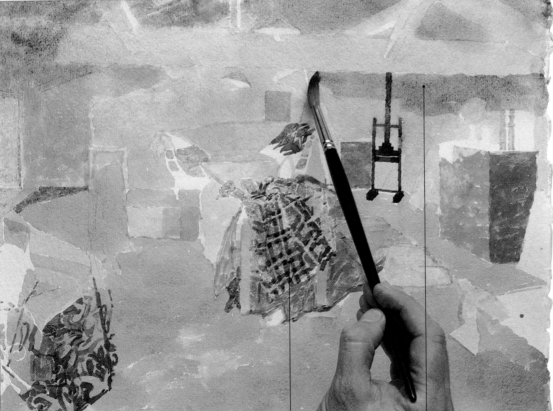

Halfway stage
Simple washes of flat color have built into a pattern of balanced tones and colors. No one area is worked on more than is necessary to cover the paper at this stage.

Patterned fabrics and furniture are suggested with swift lines of color, to create interesting features.

A subtle glaze suffuses the surface with color, blending separate areas and uneven elements.

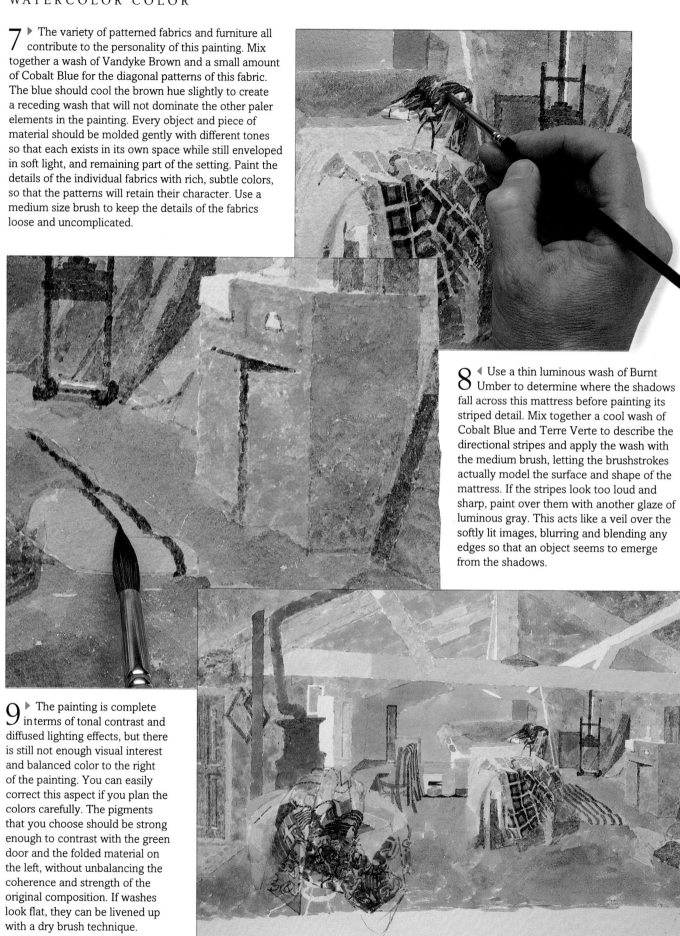

7 ▶ The variety of patterned fabrics and furniture all contribute to the personality of this painting. Mix together a wash of Vandyke Brown and a small amount of Cobalt Blue for the diagonal patterns of this fabric. The blue should cool the brown hue slightly to create a receding wash that will not dominate the other paler elements in the painting. Every object and piece of material should be molded gently with different tones so that each exists in its own space while still enveloped in soft light, and remaining part of the setting. Paint the details of the individual fabrics with rich, subtle colors, so that the patterns will retain their character. Use a medium size brush to keep the details of the fabrics loose and uncomplicated.

8 ◀ Use a thin luminous wash of Burnt Umber to determine where the shadows fall across this mattress before painting its striped detail. Mix together a cool wash of Cobalt Blue and Terre Verte to describe the directional stripes and apply the wash with the medium brush, letting the brushstrokes actually model the surface and shape of the mattress. If the stripes look too loud and sharp, paint over them with another glaze of luminous gray. This acts like a veil over the softly lit images, blurring and blending any edges so that an object seems to emerge from the shadows.

9 ▶ The painting is complete in terms of tonal contrast and diffused lighting effects, but there is still not enough visual interest and balanced color to the right of the painting. You can easily correct this aspect if you plan the colors carefully. The pigments that you choose should be strong enough to contrast with the green door and the folded material on the left, without unbalancing the coherence and strength of the original composition. If washes look flat, they can be livened up with a dry brush technique.

10 ◀ Mix a luminous wash of Ivory Black that is dark to conceal the details of the old chest. Transform the chest into an opened cupboard so that the original wash shows through as its interior. Use small touches of saturated Hooker's Green to create a backgammon board that balances the green color of the door. Such changes should improve the proportions of color and balance the tones. Deeper shadows will also heighten the tranquil atmosphere. A slight shadow over the top of the cupboard enables its lower half to glow beside the dark tones, and give a sense of reflected light at the far side of the room.

USING GOUACHE

If you overlay too many washes to create a dark tone, your colors may become muddied and lose their freshness. Gouache is an opaque rather than a transparent paint, and is very effective for concealing these cloudy colors. The chest below has been overpainted with gouache on the left, and although the density of the pigment is greater, the clarity and brightness of this area is stronger than the dull washes on the right. Gouache is also good for painting highlights on toned or off-white paper.

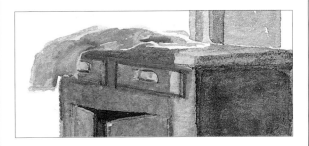

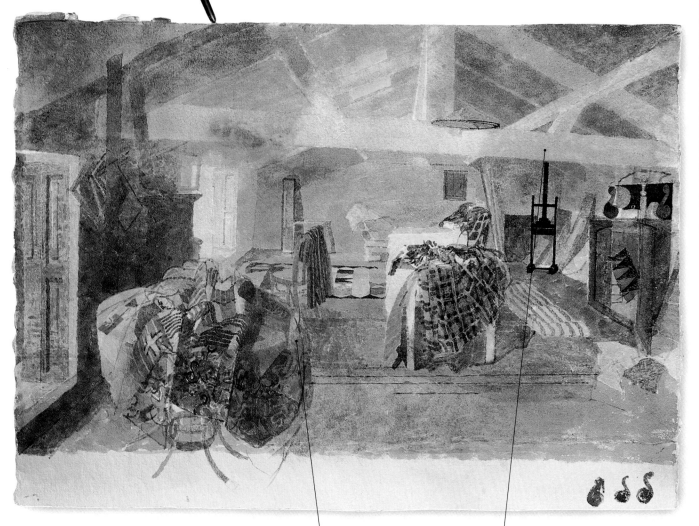

Low-key Interior

Washes of transparent color create a gentle luminosity throughout the painting. Dark recesses are penetrated by soft light, and subtle hues define and describe the objects.

Darker tones and shadows are more muted than lighter areas. Their edges and details are softer and less defined to give a sense of depth.

Soft, glowing colors are enhanced by areas of cool, luminous gray to create the illusion of surfaces taking and reflecting light.

GALLERY OF LIGHT

LIGHT INTENSIFIES OR MODIFIES the hues, tones, or temperatures of every color in these paintings, to capture a range of exciting sensations and subtle rhythms. The effects of light on a scene transform both ordinary and unusual compositions into fascinating studies of color and tone. The American artist John Marin interpreted the effects of light with pure, unmixed color. By contrast, the English artist Thomas Girtin allowed the white of his paper to reflect back the light through toned washes, to heighten the luminosity of his painting.

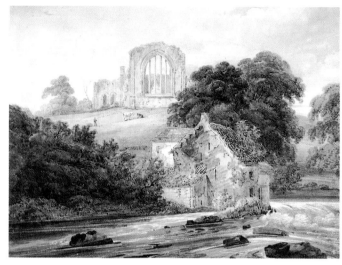

Thomas Girtin, *Egglestone Abbey*, c.1797-98
Girtin abandoned the traditional English watercolor method of painting gray underlayers and instead allowed light to reflect off the surface of his paper, to give each of his washes a transparent brilliance. He also rejected the popular palette of subdued colors and used strong colors in a naturalistic and atmospheric way. The warm browns and ochres in this painting create a rich, dense landscape, and strong, cold blue washes across the sky give a powerful sense of clear light.

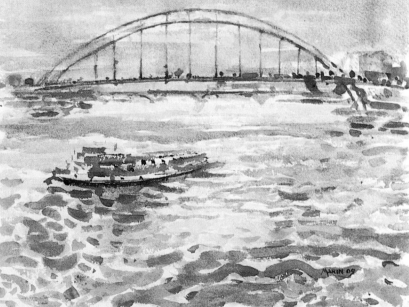

Individual strokes play across the paper as self-contained elements of pure color and light.

The source of atmospheric light in the painting is defined by a thin wash of luminous yellow.

John Marin, *River Effect, Paris*, 1909
Marin's watercolors are charged with energetic color and expressive line. Considered one of America's first watercolor modernists, he acknowledged the new dynamism of Cubism and Futurism, while still incorporating the essential beauty and balance of the natural world in his work. This scene has individual brushstrokes weighed down with pure color. The white paper surrounding each line heightens the pale luminous yellow light flooding across the scene. Hues are cool rather than hot, to imply the fading light of a sunset stretching along the river. The water looks quite realistic as the weighted lines of blue and mauve echo the constant motion of water. Marin avoided mixing his pigments into different tones, to ensure that his saturated color created the maximum vitality and mood.

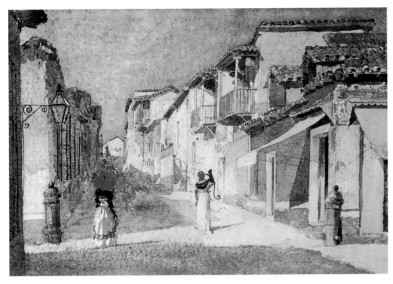

Winslow Homer, *Street Scene, Havana*, 1885
Homer preferred to work in the open to retain the freshness and vitality of the scene he painted, and his pictures are permeated with atmospheric light. Homer had a strong sense of composition and color, and he used broad brushstrokes of saturated pigment to create a powerful scene. He captures the effects of both the strong afternoon sun highlighting the deep folds of a woman's dress and large shadows created by a canopy and buildings. These warm yellow buildings reflect the hot glow of the sun, which permeates the whole street with a sleepy afternoon radiance. Intermittent touches of saturated red enliven the scene, while areas of very pale light wash suffuse the picture with bright light.

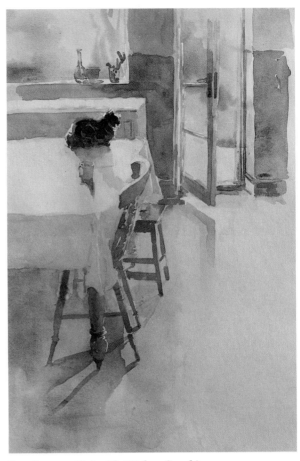

Sue Sareen, *Cat with Kitchen Sunshine*
Sareen's paintings of domestic scenes are absorbing studies of variations in color and tone and of the way in which light models, illuminates, and reveals images. This painting of warm, subtle tones captures late afternoon sunlight glittering on surfaces and edges and casting long shadows. The table top and floor become flat planes of spacious, illuminating color, controlled by a heavy wash of warm yellow that gives definition to the scene. Shadows lose their clarity as they elongate to give a sensation of weakening light. The cat, painted in the darkest tone with a dry brush, leads the eye to the center of the scene.

Hercules Brabazon, *Benares*, c.1875-6
Brabazon regarded watercolor as a perfect medium for capturing natural light and its effects at great speed. He combined this talent with an exquisite simplicity of detail and form. His sensitivity to the values of tone and light are reflected in this scene of Benares, India. The impressionistic nature of the details add to a sense of searing heat. The expanse of intense blue sky in the background is reflected in the waters of the river. The pale washes of the beige buildings create a bleached-out quality, and strong dark brown shadows emphasize the sense of intense sunlight and depth. Touches of Chinese White opaque watercolor paint add solidity and highlights to the smaller details of the painting.

Brabazon chose pigments that would fill this painting with sunlight and color. Impressionistic brushstrokes capture the sensation of brilliant light.

Strong, saturated blocks of bright green and blue washes are broken up by the brightly colored details of figures on the banks of the river.

WARM SUMMER LIGHT

COLOR TEMPERATURE is the most important aspect of this bright painting. The hot summer light affects the temperature, or appearance, of every color (*see* p.31), so that warm colors appear sunny and stimulating and the warmth of these hues is heightened against the contrasting cool shadows. The clear distinctions between the light and shadowed areas of the painting are achieved by keeping the warm and cool colors isolated on the palette and by applying each pigment in its purest form.

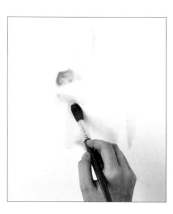

Make a sketch to determine warm and cool areas.

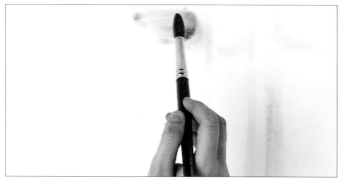

1 ▲ Use a large brush, such as a No.14, and a light wash of Cobalt Violet to sketch out the composition on hot-pressed paper. "Drawing" with the brush gives a looser, more spacious feel to the painting and avoids the inclusion of too much heavy detail.

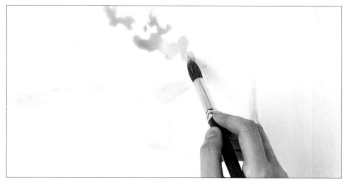

2 ▲ The background vegetation is painted with saturated color to convey a sense of heat: Cerulean Blue and Lemon Yellow Hue are strong, yet cool, colors that create the distance needed for the background. They also mix well to give a fresh, vivid green.

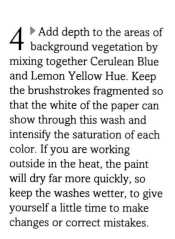

3 ◀ Build up separate areas of warm and cool color to develop contrasts of strong light and short shadows. Add a touch of Cadmium Red and Cadmium Yellow to give a warm orange-red wash to the tiles on the balcony floor. Painting a color in a light tone does not automatically make it appear warmer, so you may have to build up lighter washes in layers to achieve the right intensity.

4 ▶ Add depth to the areas of background vegetation by mixing together Cerulean Blue and Lemon Yellow Hue. Keep the brushstrokes fragmented so that the white of the paper can show through this wash and intensify the saturation of each color. If you are working outside in the heat, the paint will dry far more quickly, so keep the washes wetter, to give yourself a little time to make changes or correct mistakes.

5 ▲ Use a medium-size brush, like a No.7, to paint more detailed areas like these patterned chair cushions. A very strong color such as Cadmium Yellow can become overpowering if used too much and can also lose its luminosity if applied too thickly.

6 ▲ Apply a wash of French Ultramarine and Cobalt Violet to the doorjamb with the medium brush, to create strong shadows. The violet in the wash will help complement the yellows, while the blue will retain the coolness necessary to heighten the warm colors.

8 ▲ Apply some dots of saturated Permanent Rose with a small brush, such as a No.4, to create definition and to contrast with the green foliage. If the washes look too pale, add some more intense color.

7 ▲ Apply a light wash of pure Cadmium Yellow around the edge of the balcony, leaving some areas of white paper free to give the sensation of hot, strong midday sunlight striking the floor. A mix of Cadmium Yellow and Cadmium Red creates a luminous tone of yellow-orange to paint over the lighter tiles. Continue to layer the warm colors on the tiles, until the desired level of intensity and heat is achieved.

Materials

Color range

Tonal range

Lemon Yellow Hue

Cadmium Yellow

Cobalt Violet

Cerulean Blue

Cadmium Red

French Ultramarine

Permanent Rose

No.4 synthetic brush

No.7 sable brush

No.14 synthetic /
sable mix brush

The violet tones of the ceiling create an inviting sense of shade.

A line of Cadmium Yellow adds to the impression of direct sunlight.

Halfway stage
The vegetation is built up with economical and quick strokes, allowing the white paper to blend with the fragmented hues to create a lively, colorful atmosphere. The sky, painted with a pale blue wash, gives a feeling of white midday heat bleaching out the colors.

The glass panes of the doors are painted simply with a cool wash of Cerulean Blue to create a shiny, reflective feel.

The shadowed areas of the balcony are painted in receding cool colors, but the doorjamb is painted with a slightly warm violet wash. This pushes it into the foreground of the picture and creates a sense of perspective.

9 ▲ Paint the chair by using the negative shapes of the white paper to represent the metal frame. Use a small brush to paint a French Ultramarine wash on the shadowed area of the chair leg. Make sure you use strong pigments for the details; if too many layers are painted, the crispness of the object will be lost.

10 ▲ Make the balcony floor advance into the foreground by adding a deeper wash of Cadmium Red and Cadmium Yellow over the tiles with the medium brush. Fragmenting this wash will allow the areas of lighter color underneath to show through your final wash. Use the same brush to bring the tablecloth to life with stripes of strong Cobalt Violet.

11 ▲ If there is still not a sufficient contrast of temperature in the picture, paint the shadows again with a cooler blue wash to heighten the warmer pigments. Paint pure Cerulean Blue on the glass panes of the door with the medium brush, to create colder reflections, and use bold brushstrokes to emphasize the short, sharp shadows produced by hot sunshine. Reflections should be built up of simple but strong contrasts of light and dark tone.

12 ▲ If a wash is too strong, or an area becomes too solid and heavy, take out the wash lightly with a sponge or paper towel, to let the underlying wash or paper show through again. Allow the wash you have sponged to dry thoroughly before you paint over or around it otherwise, new colors may bleed in.

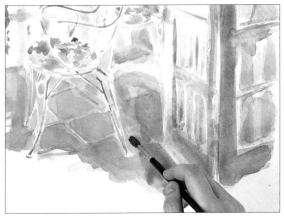

Sponge

13 ▲ Use the small brush to redefine details or to apply fresh color. If the chair appears lost in the painting, apply a fresh wash of Cerulean Blue to give cleaner and cooler shadows and better definition.

14 ▲ Paintings can be spoiled through overworking, so be sparing with your final touches to retain the freshness and translucence of the picture. Apply a final wash of Cadmium Red to add depth to the tiles.

Warm Summer Light

Painting negative shapes and shadows allows white paper to represent strong sunlight falling on objects, giving a "white-hot" feel to the picture. Layers of strong pigment are more intense and stimulating than pale weak tones, and they convey bright sunshine and lively color. The blue and violet shades in this painting both complement the warm orange and yellow tints and enhance them, making each hue vibrate and glow.

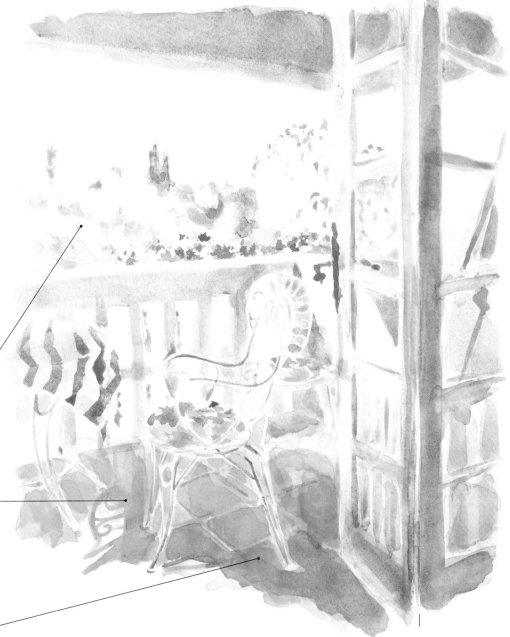

Keep details generalized and simple by painting with loose, economical brushstrokes.

Different washes of Cadmium Yellow and Cadmium Red on the floor create a rich mosaic of radiating colors.

The tiles to the right have violet undertones as they move into the shadows and become cooler.

COOL AUTUMN LIGHT

Make some sketches outside to study the sense of perspective created by the warm and cool hues.

THIS AUTUMN LANDSCAPE relies for its success on the reaction of warm colors in a cool setting. The autumnal atmosphere is achieved by building up layers of warm, earthy colors for the tree and surrounding it with cool, receding blues for the hills and sky. The sense of depth in the painting is heightened by the use of strong light and dark contrasts in the foreground and of hazy details in the distance. The skyline right at the top of the painting contributes to a powerful sense of aerial perspective.

Test the four predominant colors of Cobalt Blue, Raw Sienna, Burnt Sienna, and Olive Green as swatches of color, to discover the tones and harmonies they create.

1 ◀ Sketch out the basic images with simple blocks of Cerulean Blue, Raw Sienna, and Cobalt Blue on NOT paper, using a brush such as a No. 6. These initial cool washes will determine the temperature of the landscape, but they should not stain the paper if sponged off.

2 ▲ Mix up a cool, luminous wash of Aureolin and Raw Sienna, and paint it broadly over the distant hills near the horizon. Continue this process of building up a layered and harmonious landscape using light washes.

3 ▲ Apply washes of Cobalt Blue and Olive Green to develop the basic shapes of fields, trees, and houses. The dark green creates a subtle harmony with the warm browns and the cooler, misty blues. Use a sponge to lift out any areas that upset the balance of the composition.

4 ▶ Introduce warm hues of Brown Madder Alizarin, Raw Sienna, and Burnt Sienna for the autumnal leaves of the main tree in the foreground. This is the focal point of the picture, so apply the washes thickly to make them glow against the surrounding cool hues. Build up the form of the tree with loose, rough brushstrokes to create large shapes of color and to suggest, rather than describe, detail.

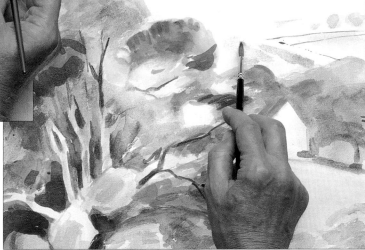

5 ◀ Paint the fine lines of the distant fields with a pale mix of Cerulean Blue and Indigo, using a brush such as a No.5. Paint trees in the far distance with strong, receding blues to add to the depth of the picture, and use mixes of Olive Green and Indigo for the fir trees in the middle distance. Apply washes of Brown Madder Alizarin and Yellow Ochre to the foreground.

6 ▶ Give the landscape a subtle harmony by laying a thin Olive Green wash over the blue and yellow fields, to temper the intensity of each pigment. Keep distant images small and undefined, to create a stronger sense of perspective.

Materials

Color range

Tonal range

Cobalt Blue

Raw Sienna

Burnt Sienna

Cerulean Blue

Aureolin

Brown Madder Alizarin

Sepia

Olive Green

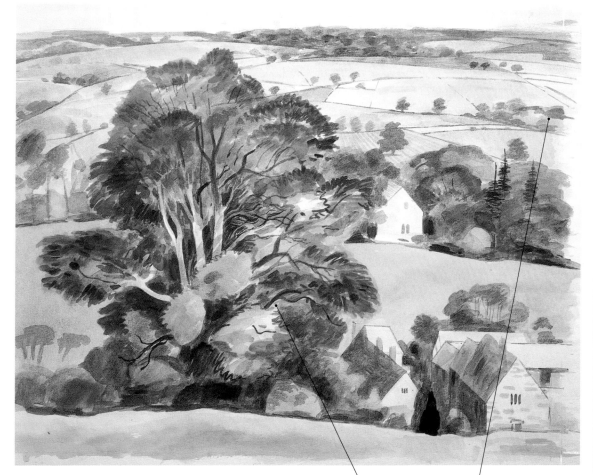

Halfway stage
The colors of the dying leaves on the tree are echoed in the houses and bushes in the foreground, pushing these areas of strong color forward against receding blues in the middle ground and distance.

The tonal structure is built up by using the four main mutually enhancing colors.

The weaker washes in the background create an illusion of space and depth.

49

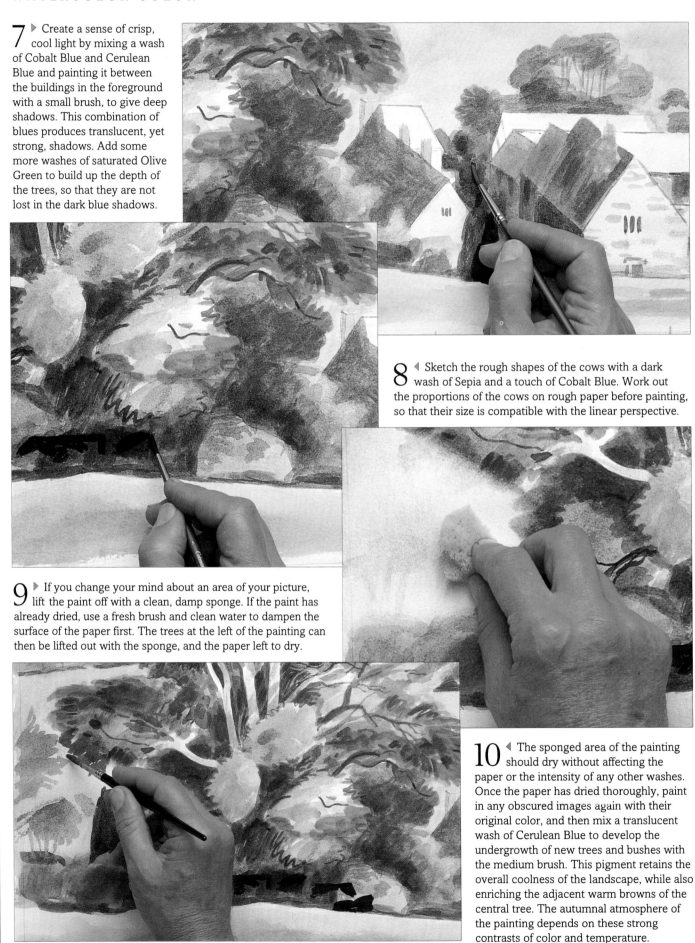

7 ▷ Create a sense of crisp, cool light by mixing a wash of Cobalt Blue and Cerulean Blue and painting it between the buildings in the foreground with a small brush, to give deep shadows. This combination of blues produces translucent, yet strong, shadows. Add some more washes of saturated Olive Green to build up the depth of the trees, so that they are not lost in the dark blue shadows.

8 ◁ Sketch the rough shapes of the cows with a dark wash of Sepia and a touch of Cobalt Blue. Work out the proportions of the cows on rough paper before painting, so that their size is compatible with the linear perspective.

9 ▷ If you change your mind about an area of your picture, lift the paint off with a clean, damp sponge. If the paint has already dried, use a fresh brush and clean water to dampen the surface of the paper first. The trees at the left of the painting can then be lifted out with the sponge, and the paper left to dry.

10 ◁ The sponged area of the painting should dry without affecting the paper or the intensity of any other washes. Once the paper has dried thoroughly, paint in any obscured images again with their original color, and then mix a translucent wash of Cerulean Blue to develop the undergrowth of new trees and bushes with the medium brush. This pigment retains the overall coolness of the landscape, while also enriching the adjacent warm browns of the central tree. The autumnal atmosphere of the painting depends on these strong contrasts of color and temperature.

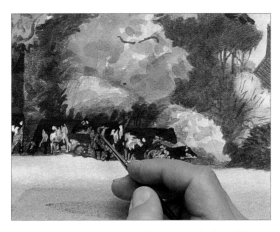

Materials

Sponge

No.1 sable brush

No.5 synthetic brush

No.6 sable brush

11 ▲ Allow the dark washes to dry before filling in any more detail on the cows. Apply a glaze of white acrylic paint with a fine brush to highlight details. It is important to apply acrylic paint thinly on this type of work so that you can apply a further wash of watercolor over the area immediately. A thin wash of the dark mixture over the cows gives an impression of cold shadows cast by the tree.

12 ▷ Paint thin washes over different areas of the landscape to harmonize and balance various elements. Mix a wash of Cerulean Blue and Cobalt Blue to deepen shadows and cool down areas so that the atmosphere of the painting is that of a clear and chilly autumn day. Allow the silhouette of the main tree to stand out against the background.

Cool Autumn Light
The unusual aerial and panoramic perspective of the painting is built up using contrasts of warm and cool color, drawing the viewer's eye to the warm tones of the central tree, and away over the fields to a cool misty horizon. The sensation of light and seasonal change has been achieved with basic perspective techniques and cool washes of pure color.

A rich tapestry of strong browns and oranges makes the tree the focal point of the work.

A final thin glaze gives the painting a sense of unity and balance while preserving translucence.

GALLERY OF ATMOSPHERE

THE POWER OF WATERCOLOR to capture atmospheric conditions is due partly to its fluidity and partly to its ease of handling, which allows a greater spontaneity. Many artists have used color most effectively to describe a range of weather conditions. Winslow Homer cooled his bright palette to portray an oncoming tropical storm, while another American artist, Edward Hopper, used strong washes of bright color and sharp shadows to convey an intense light.

Noel McCready, *Northumberland Rain*
This atmospheric painting describes the driving presence of tumultuous rain. McCready captures the stillness of the landscape behind a heavy veil of rhythmical rainfall, inspired by Japanese techniques. The rain has been drawn with a draftsman's pen loaded with watercolor paint. The three-dimensional effect of the landscape behind the sheet of rain is heightened by using warm colors in the foreground and strong dark blues in the distance. The pervading sense of gloom and impending darkness is created by powerful combinations of saturated color and strong impressions of light and atmosphere.

Samuel Palmer, *The Magic Apple Tree*, 1830
Palmer imbued his work with an Arcadian vision, so that his landscapes are richly textured and abundantly colored studies of an idyllic English countryside. The wealth of warm yellows and browns in this work represents the vital rustic beauty of agrarian life. There is a stark contrast between the warm glow of the valley and the brooding skies heralding darkness and the onset of winter.

The church spire, a focal point of the painting, is nestled deep in the valley and surrounded by strong autumnal hues of intense orange.

Palmer chose to describe the fruitfulness and fertility of nature in his paintings. He used rich colors for the details of this landscape.

Winslow Homer,
Palm Trees, Nassau, **1898**
As Homer's career developed, he came to rely on transparent watercolors rather than on gouache. The Caribbean light and the lush tropical colors of Nassau influenced Homer's palette toward brighter pigments and at the same time encouraged a new fluidity and freedom in his brushstrokes. The strong colors in this painting are full of light, despite the gray, windy conditions they evoke. The visual power of the composition is heightened by the exotic blue of the sea, and the loose, dark strokes of the palm leaves stretching out to the edges of the painting. The bold washes of saturated blue recede with a distinct coolness to create depth and perspective, while individual brushstrokes of different pigments merge together to form a warmer foreground. This subtle fusion of colors also contrasts with the large expanse of cool gray sky that dominates the whole painting with a translucent, luminous quality.

Sine Davidson, *Italian Café*
Davidson has used three main colors in this bright, sunny scene to create a spectacle of vibrant, dominating color. Architectural structures and metal spiral chairs have been painted spontaneously and simply to allow pure color to feature more prominently than actual shapes. Individual strokes of saturated pigment mingle together to create a fusion of different hues. The sharply defined shadow of the umbrella and the strong pigments react with the whiteness of the paper to give an unrestrained clarity of color.

Powerfully strong sunlight has transformed familiar everyday buildings into unexpectedly grand and beautiful structures. The light reveals and isolates parts of the building, turning some areas into flat planes of intense color.

Edward Hopper, *St. Francis Tower,* **1925**
Hopper was attracted to artificial objects and cities, and his paintings depict both a powerful architectural monumentality and an uneasy feeling of solitude. People are often isolated within stark interiors or alienated on deserted street corners. Hopper always worked on location, and he had a striking perception of structure and light that influenced the character, color, and surface of the buildings he painted. The short midday shadows in this work heighten a pervading sense of loneliness, and the intense heat is emphasized by extremes of light warm ochre and cool shades of blue. The absence of active movement, or of people passing by, creates an eerie silence throughout the painting and strengthens the significance of the buildings. The saturated washes have been painted with a direct simplicity that conveys both the heavy mass of the stone structure and a luminous quality of strong light.

EXPRESSIVE COLOR

THE HUMAN FIGURE reveals a complexity of form, surface reflections, and colors. The lights and shadows that accentuate the existing hints of color in flesh tones can be exaggerated to express the mood and character of a person, or to heighten an emotional or a cultural aspect of the subject. Using a limited palette of colors in an unusual way can transform a portrait from a descriptive recording, to an expressive interpretation full of vitality and personality. The fewer colors used, the stronger the statement.

The effect of cool light
Strong light affects the emotional content of a painting. If the light is cold, the reflections of skin tones will appear quite dramatic, and the shadows sharp and angular. Vivid colors emphasize a fresh, modern character.

Unusual color
The washes of French Ultramarine and Winsor Green create both a cool, expressive mood and deep, receding shadows. The pure pigments are mixed on the paper to retain their optimum strength and luminosity.

Washes of French Ultramarine and Winsor Green create unusually strong and powerful shadows.

The effect of warm light
Warm light creates a golden atmosphere that affects each color and heightens the naturalistic tones of skin. Shadows are softer and less dramatic, but they still reflect unusual colors and create some interesting, striking effects.

Washes of Cadmium Orange, Alizarin Crimson, and Raw Sienna are used for the highlights.

Expressive color
Sharp contrasts in color and tone create vitality and movement in the composition. These qualities redefine the form and structure of the body as strong planes of bold color.

Translucent pigments
These pigments are overlaid on the paper so that they mirror the translucence of skin and glow gently to give a sensation of warmth and light.

Cadmium Red, Alizarin Crimson and light washes of Burnt Sienna give rich, warm highlights.

A mix of French Ultramarine and Winsor Green and dark washes of Burnt Sienna create subtly atmospheric shadows.

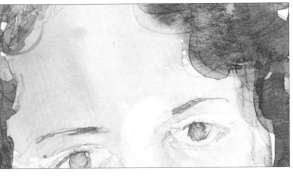

Cultural Influence
The studies of this young girl (also painted on pp.56-57) exaggerate certain qualities about her in two ways. This painting heightens her Indian background by using strongly evocative colors synonymous with her culture. The hues are as pure and as intense as possible to create an immediate association.

Interpreting form
These powerful hues interpret rather than describe the form and detail of the head. Some flat washes are overpainted with dark hues to suggest depth.

The purple wash is produced by mixing French Ultramarine and Alizarin Crimson.

Pure pigments of Cadmium Red and Cadmium Yellow are painted with loose brushstrokes.

Bold shadows
The shadows around the neck are painted with strong, bold color that is as flat and expressive as the washes on the face. The cool quality of the green wash, however, helps it recede beside the brighter pigments of red and yellow.

Rich reds and purples dominate the picture and contrast effectively with washes of green and yellow.

Dramatic color
A limited palette of stronger colors will create a forceful statement. This painting exaggerates the youth and vitality of the girl, and colors are as saturated as possible so that they sing against one another.

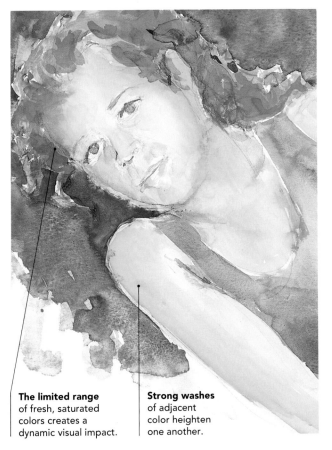

Heightened color
The face is modeled with pure pigments to retain their maximum tinting strength. The intense wash of French Ultramarine in the background heightens the warm washes of Cadmium Red and Cadmium Yellow, so that they pulsate.

Color influence
The depth and shape of the face in this study is also built up with cool green washes of Lemon Yellow Hue and Winsor Blue that are more expressive than descriptive. The dress, mixed from Alizarin Crimson and French Ultramarine, and the green washes complement the yellow and red hues.

The limited range of fresh, saturated colors creates a dynamic visual impact.

Strong washes of adjacent color heighten one another.

PORTRAIT STUDY

U SING THE POWER OF SUBTLE COLOR to capture the mood and character of this young girl produces an interesting and evocative slant to a portrait study. The fluidity, subtlety, and translucence of watercolor combine with washes of slightly unnatural, expressive color to build up an impression of youth and a warm, rich atmosphere. The girl is lit in an interesting way, so that the shadows created affect the structure of her face, and colors from the surroundings are reflected in her skin tones.

The girl's rich skin tones are enhanced by the light.

1 ▲ Sketch the features and proportions of the face, but keep them simple. As this girl's skin has a rich reddish brown quality, apply a light wash of Cadmium Red, Raw Umber, and Yellow Ochre with a wash brush, using sweeping brushstrokes.

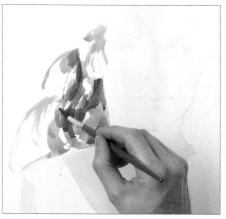

2 ▲ Use a medium-size brush, such as a No.7, to apply a wash of Vandyke Brown and Permanent Rose to build up the hair with rough, swift strokes. Adding Oxide of Chromium to Vandyke Brown cools the wash so that it recedes. Building up layers in this way creates a variety of tint and shade to produce volume in the hair and prevent it looking flat and heavy.

3 ▲ Mix together a large wash of Cadmium Red and Yellow Ochre and apply it with the medium brush around the neck and chest, to create angles and shadows. The jaw also needs to be defined against the dark tones on the neck. A touch of Oxide of Chromium helps the wash deepen and recede away from the highlighted jaw.

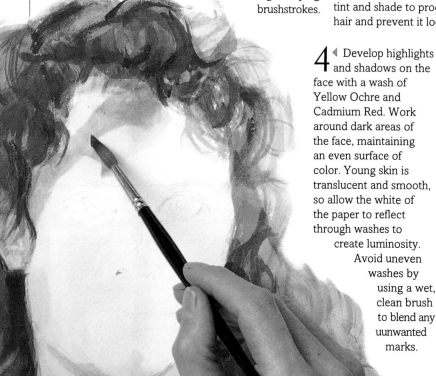

4 ◀ Develop highlights and shadows on the face with a wash of Yellow Ochre and Cadmium Red. Work around dark areas of the face, maintaining an even surface of color. Young skin is translucent and smooth, so allow the white of the paper to reflect through washes to create luminosity. Avoid uneven washes by using a wet, clean brush to blend any uunwanted marks.

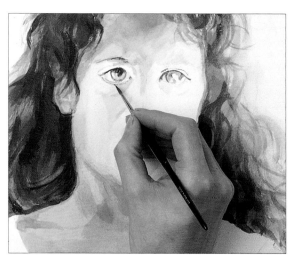

5 ▲ Use a fine, small brush for eye details. The eye is sphere-shaped, so use curved brushstrokes. Paint a faint wash of Cerulean Blue across the white of the eye to show the reflections of surrounding lights. Begin with light tints, and gently build up depth.

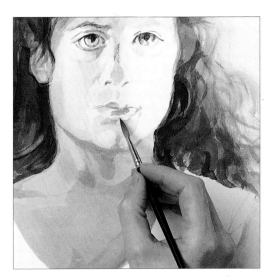

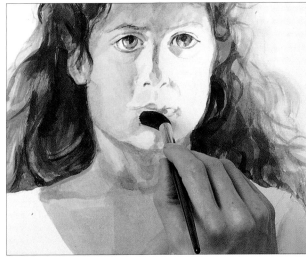

6 ▲ Define and sculpt the lips with light tints and dark shades of Cadmium Red and Permanent Rose, using a medium brush. Soften the edges of the lips to blend them in with the rest of the face, using a clean damp brush.

7 ▲ Paint shadows and depressions around the mouth to give it more definition, but avoid overstating the lips. Mix a subtle blend of Oxide of Chromium with Raw Umber and Yellow Ochre to give a cool wash that will naturally recede into the cleft of the chin.

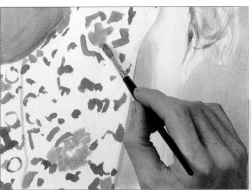

8 ◄ Paint a simplified pattern of the dress with pure washes of Cerulean Blue, Cadmium Red, and Cadmium Yellow. Mix some Permanent Rose with a touch of Chinese White paint, to create an opaque pastel-colored wash. Concentrate on creating a general impression of the dress pattern, rather than describing the intricate details.

Portrait Study

Powerful interior lighting determines the mood of the painting and accentuates the highlights and deep shadows of the face and neck. Softer lights would smooth the planes and facets of the body to produce a gentler, more molded, effect. Flesh tones are influenced by the color of the lighting and the hues reflected from other objects. The color of the light also affects the highlights in the hair. Warm and cool washes, rather than harsh outlines, bring the face into relief.

Prominent areas of the face have warm washes containing Cadmium Red, which warms the pigments and makes them advance.

Shadows and depressions have darker washes containing Oxide of Chromium, a cool green, to help create depth and contrast.

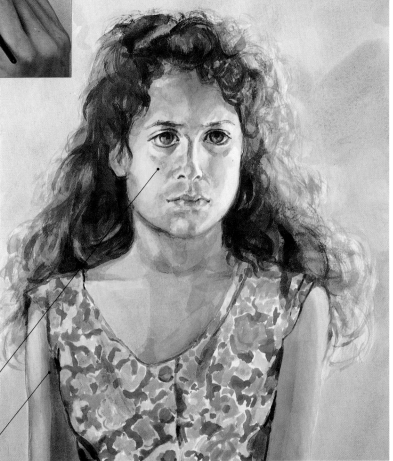

Materials

Color range

Tonal range

Vandyke Brown

Raw Umber

Yellow Ochre

Cadmium Yellow

Oxide of Chromium

Cerulean Blue

Permanent Rose

Cadmium Red

No.2 sable brush

No.7 sable brush

No.14 synthetic wash brush

57

COLOR AND PATTERN

INTRODUCING PATTERN AND SHAPE into a picture allows you to use color in an expressive and unusual way, freeing a work from a strictly descriptive realism. Color itself can become a repeating design, picking up on the light and the shapes of objects and translating them into flat planes of powerful color and suggested form. Stylized shapes and repeating patterns can also produce strong vibrant rhythms and symbolic imagery within a composition. Using pure color and repeating shapes in this way creates a stronger expression and lyricism.

Composing with shape and color
One of the easiest ways of building a series of repeating shapes and patterns into a painting is to concentrate on one still life in which the shapes of different objects echo each other. Using colors that relate to one another rather than to the natural color of these objects also conveys mood and movement.

Color themes
Colored lighting affects the mood and expression of a composition and establishes a strong theme through which to interpret objects and shapes, or emphasize their clarity in a particular light. A cool blue light over the same still life changes the mood and the detail of certain objects, projecting a sharp visual pattern.

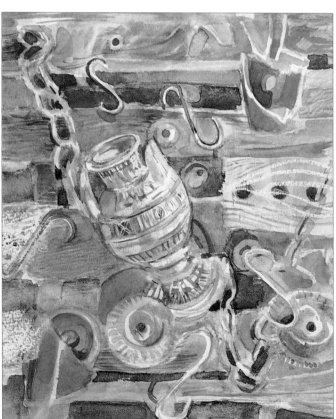

Emphasizing shape
This painting, based on the still life above left, echoes and simplifies the effects of the warm yellow light over every object and exaggerates their cool violet-blue shadows. Repeating shapes and lines create a strong visual design, heightened by a limited range of strong, simple colors.

Interesting negative shapes and dark shadows create movement and depth.

Circles and curves repeat and echo each other across the paper. Small lines and horizontal planes of strong, flat color balance the composition.

Stylized patterns

This picture stylizes the most obvious images of the still life and employs bold, flat, striking color to suggest their shape and form. Using just three strong colors creates a repeating pattern in itself, so that the same hues are used to imply both positive and negative shapes.

Painting from memory, or turning a picture upside down, can help reduce objects to their purest form.

Close up, objects lose their form and depth and become flat shapes of repeating color.

Restricting the palette to three dominant colors gives strong visual impact.

Random markings create a stylized pattern that becomes the most obvious link to the original vase.

The range of strong, cool, expressive colors pervades the work with atmosphere and mood.

Atmosphere

This work captures the pervasive mood created by the cool blue lighting of the second still life. The painting emphasizes the lines and shapes produced by the interaction of new cool hues, ignoring the relationship and position of objects within the original composition.

Cool greens and blues, such as Terre Verte and Cobalt Blue, mingle with the cool, unsaturated hue, Indian Red.

Color unity

This composition has dissected the original still life into a series of random images linked only by their similar shape. The rhythm of a few repeating hues hold these disparate images together.

Strong repeating hues link individual shapes.

Complementary reds and greens enhance each other.

Objects become floating shapes, stylized as pure form and line.

PATTERN IN LANDSCAPE

The inspiration for this painting came from stained-glass window studies of a waterfall.

USING PATTERN AND TEXTURE in a painting allows you to exploit the full potential of expressive, pure color. The pattern in this work is composed of a series of recurring shapes, lines, and tones, which can all be determined and defined by color. By using a variety of different brushstrokes, you can create a visual tapestry of dots and lines that will have the appearance of random patterning. This landscape is inspired by a stained-glass image of a waterfall, but you can use your imagination to combine negative shapes and texture with unusual colors to express your own ideas and interpretations.

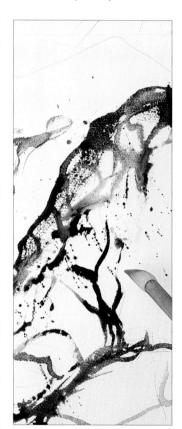

1 ◀ The aim of this painting is to work quickly and fluidly, building up a web of textural marks and accidental patterns. Develop a basic composition with a dark wash of Prussian Blue, Sepia, and Cadmium Red, using a large brush; Chinese brushes are particularly good for expressive lines of color. Load the brush with the wash and paint sweeping brushstrokes over the paper. Flick the brush occasionally, to give random spatterings and splashes. The rough, textured paper is strong and not immediately absorbent, so pigments sit in patterns on the surface.

2 ◀ Drag the brush lightly across the rough surface, so that it picks up the grain of the paper. Mix Cobalt Blue and Prussian Blue for a dramatic sky. Use strong, rich washes of exaggerated color. Try to maintain the freshness of the picture by not overpainting or adding too many layers of different color.

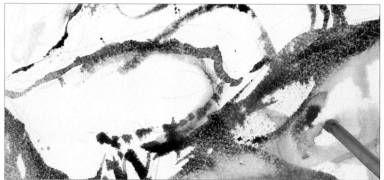

3 ◀ Blend the various markings together with a wash of Yellow Ochre and Cobalt Blue. This mix produces a dark green mossy hue, rather than a harsh vibrant green. Using a wet-in-wet technique and a fine brush will create random patterns.

4 ▶ Add pure dabs of Carmine to the horizon to produce a dramatic contrast with the earthy colors of the mountain banks. While the wash sits on the surface of the rough paper, manipulate it randomly with a small Chinese brush into abstract shapes and lines. The rich Carmine pigment creates an unnatural, almost fantastical, horizon against the surrounding darker washes. The effect is a two-dimensional pattern of strong, pure colors.

5 ◀ Strengthen the bank on the far side of the waterfall with a deep, saturated wash of Prussian Blue, using a large brush. Try holding the brush as upright as possible to paint unrestrained and interesting shapes, rather than careful, deliberate strokes. Drag the brush from the top of the waterfall, pushing the wash as far as possible in one continuous line of free movement down the length of the paper.

6 ▲ Wet the left side of the painting with water, and apply Yellow Ochre with a medium size brush, so that each brushstroke takes on a blurred, abstract look and spreads randomly over the paper.

Pattern in landscape

Random patterns of dark pigments give striking negative shapes and evoke a craggy landscape. Areas of broken color echo the natural patterns of the landscape while creating unusual and dramatic color combinations.

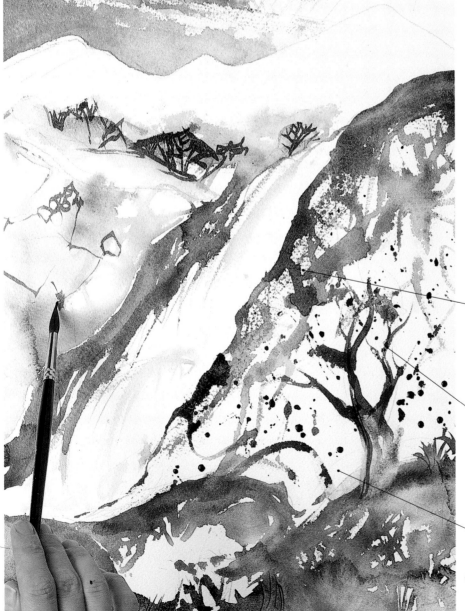

The whole landscape is made up of a visual pattern of individual dots and lines.

The painting allows color to further define the patterns inherent in nature.

The strength of each hue is heightened by visible areas of white paper.

Materials

Color range

Tonal range

Yellow Ochre

Sepia

Cadmium Red

Carmine

Cobalt Blue

Prussian Blue

Sponge

No. 7 sable brush

Small Chinese brush

Large Chinese brush

GALLERY OF PATTERN AND SHAPE

BY CONCENTRATING ON PATTERN and shape in a painting, these artists have escaped the confines of realism to celebrate the power of pure shape and color. The English artist John Sell Cotman painted intricately detailed areas with subtle dark hues that contrast with the rhythmical patterns of bold color by the French artist Sonia Delaunay.

Soft, luminous shadows are repeated across the painting to give the composition depth. Structural details are simplified and enhanced with glowing color.

Areas of the painting are covered with broken color and suggested shapes. Cotman preferred not to define intricate details that could swamp his subtle rhythms.

John Sell Cotman, *Doorway to the Refectory, Kirkham Priory, Yorkshire,* **1804**
Cotman had a fine sense of structure and pattern in his paintings. He created these elements by contrasting dark silhouettes against light areas and by using soft, luminous hues in darker areas. Dark leaf shapes cover the right side of the paper in a rhythmic pattern, while repeating colors shine through the dark shadow on the left. Cotman tended not to swamp the expression of a work with too much detail, so areas of broken color give substance to his composition. Brickwork details to the right of the doorway add definition to the painting. The flat luminous wash on the top left is also broken up into surface pattern by the faint brick markings.

Sunlit areas of skin glow with luminous yellow washes, complemented by cool violet-blue shadows.

The painting is dominated by repeating circles and patches of light.

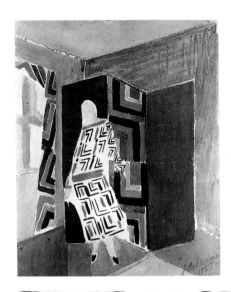

Sonia Delaunay, *Woman*, 1925
Delaunay, with her husband Robert, embodied the new dynamism of art at the start of the twentieth century. She celebrated a modernity of pure color and hue, developing an expressive style of abstract geometric form and pure pigment. These colors have a direct, liberating impact, creating rhythm and movement. Rich reds quicken the patterns, while geometric abstractions and dark areas repeat and echo across the painting.

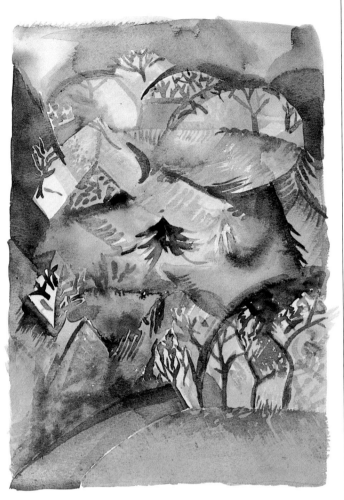

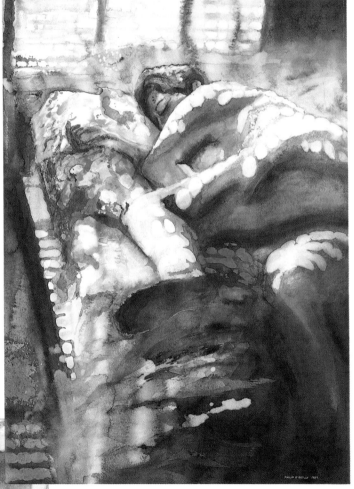

Rachel Williams, *Valley Below*
This painting illustrates how pattern and shape work in the form of pure stylization. The artist has built up a series of simple, yet dramatically exaggerated, shapes and planes of color. Mountains and trees have been reduced down to their most basic, or symbolic, forms. The receding blues, warm greens, and yellows define shape and rhythm rather than depth and space. Curved brushstrokes and patterns within the stylized shapes echo the rhythms of nature and give the painting movement and energy. The river is painted as an exaggerated, simplified plane of color, leading the eye into a complicated rhythm of organic shape and dramatic form.

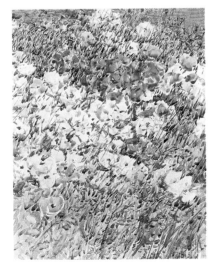

Childe Hassam, *The Island Garden*, 1892
Hassam, one of the most impressionistic of American watercolor artists, captured nature spontaneously, evoking the fleeting effects of light with vivid color and pattern. This work is typical of his unusual approach of closing in on a scene to produce a flat, two-dimensional image of dots and lines and intense colors.

Philip O'Reilly, *Siesta*
O'Reilly structures his pictures with contrasts of deep color and intense light, surrounding strong shapes and patterns with soft texture. The exaggerated perspective of this work forces the eye to focus on circular patterns and horizontal lines over and around the sleeping figure. Hazy, undefined areas of color drift out to the edges, diffusing the bright light shining through the window. A strong interplay of warm and cool color defines the depth and structure of the painting.

63

ABSTRACT COLOR

*Dynamic color evokes a
powerful reaction.*

ABSTRACT ART PULLS AWAY from reality and returns to the essential questions of light, space, form, and color. It relies for its meaning and message on sensations of line and form and emotive color associations. Abstract paintings can be composed in a number of ways – here, the first painting has been built up of invented shapes that do not have any conscious association with the real world, while the second painting distills the natural appearance of a mountain scene into a lucid composition of shapes and colors that evoke its essential character. Colors can be at their most dramatic or their most sublime in these abstract paintings, influencing the expression and energy of each work.

Original Abstract

1 ◀ Using heavy, textured paper to withstand the wet washes, apply saturated washes of Permanent Rose and French Ultramarine with a large brush. The composition develops from the spontaneity of the wet washes and is free from any real associations. The range of colors used should be purely expressive, and the brushstrokes painted automatically.

2 ▲ Add washes of Cadmium Red to the composition and let the wet edges blend with the areas of French Ultramarine to produce a subtle shade of violet. Mix the colors on the paper rather than on the palette, so that the washes will retain their luminosity. Abstracts rely more significantly on tone, light, and harmony to give rhythm and definition to the composition.

3 ▲ The three pigments form a basic composition, hinting at shapes and with light and dark areas starting to form in the wet pools of the washes. A sponge or piece of paper towel dabbed lightly on different areas of the painting creates further unusual shapes and highlights. These unfamiliar free forms give the painting a less realistic feeling.

4 ▲ Add a strong wash of Sap Green to the painting with a large brush. The dabs of green pigment around the edge create a repeating, patterned effect that breaks up the smooth flat washes of color giving the composition movement and rhythm. The green contrasts with the Permanent Rose so that the two colors increase and enhance each other's intensity.

5 ▷ Apply final washes of intense Cadmium Red and French Ultramarine as random shapes, free from any themes or motifs. The strength of the red pigment provides a focal point for the composition and also complements the French Ultramarine washes, so the painting relies for its strength and impact on two sets of complementaries. The initial lighter tones now add to a sense of space and depth, while the stronger final washes pulsate toward the front of the painting. The powerful areas of vivid red create a fast tempo countered by quiet passages of light color.

Materials

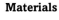
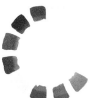
Color range

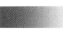
Tonal range

French Ultramarine

Sap Green

Cadmium Red

Permanent Rose

Ivory Black

Turquoise

Raw Umber

1in synthetic brush

Original Abstract
Invented forms and shapes are suggested by loose washes of color. The abstraction is heightened by the spontaneous and accidental effects of a wet-in-wet technique. Washes merge freely and settle randomly.

A mixture of dynamic color and quiet, subtle hues create a sense of space and light.

The range of tones and two sets of complementaries enhance the movement and rhythm of the composition.

Abstraction From Nature

1 ▲ This second painting abstracts a mountain scene, painted from memory, so that the composition is pared of detail and reduced to its essential character. Apply a pure wash of Turquoise with a large brush around the edges of the painting, to symbolize the sky and give an initial sense of space and light.

2 ▲ Apply a strong wash of Sap Green with broad brushstrokes to the central area of the composition. Keep the wash as bright as possible, so that it symbolizes the freshness of green vegetation. Then paint a lighter wash of Sap Green and Ivory Black over the white of the paper, to signify the shape of the mountainside.

3 ▲ Paint the simplified shape of a green tree at the right side of the mountain. Give the tree more interest and definition by adding a few light strokes of Raw Umber on top of the green image. Painting objects in their most stylized form gives them a universal symbolism and frees the painting of any specific references.

4 ▲ Glaze over the strokes of Sap Green and Ivory Black with a lightly tinted wash of Raw Umber, to subdue the intensity and coolness of the purer paints. This will help both to warm up and harmonize the other washes of color, and give the composition a feeling of space and air.

5 ◀ Lightly paint suggested forms and objects, such as birds and bushes, with a wash of Ivory Black. This will also break up the flat washes and create more interest. These stylized shapes and images also give the composition a greater range of imagery and interest. Add another wash of Turquoise to the sky, if it appears too pale against the other hues.

Abstraction From Nature

The features of this subtly atmospheric landscape are stylized into their most basic form and represented by symbolic color. This abstracts the painting away from its subject matter and turns it into a stylized image of a mountain.

Light washes of flat color eliminate any sense of depth and perspective.

Tinted hues merge together to give a feeling of stillness, space, and light.

The lack of harsh lines enhances the sensation of continuous space.

COLOR SYMBOLISM

Color is regarded as a universal language, suggesting and expressing a multitude of immediate visual associations and instinctive emotions. Color symbolism is based mainly on associations derived from nature and religions, so it can be used in art to evoke powerful responses. In the twentieth century, western artists have reaffirmed the primitive emotional powers of color in their work.

Green is an ambivalent hue, associated with poison, envy, jealousy, and decay, and also of rebirth, Spring, restfulness, and security. Green was traditionally worn as a symbol of fertility at European weddings.

Red is the strongest color in the spectrum, and it evokes powerful emotions; it also symbolizes love and passion. It can be warm and positive, yet provocative and angry. The Chinese consider red auspicious.

Black is a traditional symbol of evil. It also has ominous, mysterious associations, such as death and the unknown – a black hole in space, or a black mood. Black, however, is also seen as sophisticated.

Orange is striking and sharp, like the color and taste of the fruit. Warm oriental spices such as turmeric and saffron exude orange. In the East it has religious overtones; Buddhist monks wear saffron robes.

Blue evokes tranquility, giving a feeling of space and height. It is emblematic of truth, divinity, and spirit. Despondency is also expressed in the term "the blues." American Blues music expresses sadness and despair.

White symbolizes good as black symbolizes evil. It can suggest the ethereal through its association with purity, innocence, and cleanliness. However, it also has associations with cold, unemotional qualities.

Violet is considered enigmatic. The Christian church uses violet for some of its ecclesiastical ceremonies to symbolize the passion and death of Christ. Purple is also used to suggest royal connotations.

Yellow, with its warm qualities, is evocative of Spring and Summer. It thus symbolizes joy, youth, renewal, and growth. By contrast it is also associated with sickness and cowardice.

GALLERY OF ABSTRACTS

THE ABSTRACT STYLE evolved as a modern twentieth century reaction to traditional European concepts of art as an imitation of nature. The American Sam Francis and the German Max Ernst used symbolic color and non-representational forms to articulate their vision of the world.

Sam Francis, *Watercolor Painting*, 1957
Francis deals with light rather than the reflections of light, and his hues are saturated without losing their luminosity. Reds and blues create movement, and rivulets of color signify chance meetings in silent space.

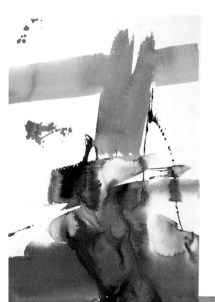

Gisela Van Oepen, *Watercolor No.564A*
Van Oepen relies on pure extremes of color and form in her abstract paintings. In this work she uses white expanses of paper to produce a balance of undefined space around a structure of powerfully bright hues. Contrasting hues of intense orange and blue recede and advance across the paper, while a small touch of vibrating red heightens the visual impact of line and color.

Max Ernst, *Landscape*, 1917
Founder of the German Dada movement, and later cofounder of the Surrealists, Ernst was one of the most successful early twentieth century artists to translate the ideas and dreams of the subconscious into art. His artistic desire to liberate the unconscious mind led him to produce some mysterious and beautiful images. In this painting, Ernst's fantastic colors and strange imagery predominate. The rich, saturated, luminous violets pulsate at the center of the composition. The strong harmony of adjacent colors that illuminates the painting shows Ernst's skill at combining theory and artistic instinct.

Areas of white space become an integral part of the composition, focusing attention more intently on the reaction of blue and orange complementaries.

Pure extremes of line and color determine the visual impact and strength of this painting. The proportions of each color are carefully balanced in the composition.

Christopher Banahan, *Venice*
Banahan has picked out the essential features of these buildings and abstracted them down to simplified images. These basic forms create an independent structure of shapes and colors that have an aesthetic appeal in their own right. Banahan aims to create an ethereal quality about his paintings, allowing the lyricism of his colors to describe the sensations of the painting. Deep shades of dark blue contrast with tints of mid-blue, creating a subtle harmony. These darker passages enhance the lighter areas so that they glow gently and give the painting a soft illumination.

Subtle variations of blue create a strong expression of mood and emotion.

Objects derived from nature are simplified into basic shapes and become unrecognizable.

Rich luminous colors enhance each other to create visual impact and strong sensations.

Ernst frequently used exaggerated shapes and forms to express his subconscious.

Carol Hosking, *Equilibrium*
Hosking's main influences are color and music, which combine with chance effects to give an experimental range of color, movement, and form. Hosking works intuitively with no preconceived ideas, so that her paints will flow freely and spontaneously. In this picture, universal shapes and symbols drawn from nature are painted with a smooth blend of colors. The strength of each pigment is controlled to avoid any dominating hues.

GLOSSARY

ABSORBENCY The degree to which the paper absorbs the paint, often due to the degree of surface sizing (sizing is the coating on the paper, usually a mixture of gelatine, water, and a preservative, that affects the hardness and absorbency of the paper).

ADJACENT COLORS Those colors literally closest to each other on the color wheel; also used to describe colors that lie next to one another in a painting. Adjacent complementary colors appear brighter together because each reinforces the effect of the other.

ACRYLIC GESSO An acrylic primer occasionally used to prepare watercolor paper when special effects are required.

ADDITIVE COLOR MIXING Color that is produced by mixing together different colored lights. It is known as additive because as each color is added, the resulting combination is more intense. The three primary colors of light are orange-red, green, and blue-violet. Orange-red light and blue-violet light produce Magenta (red) light. Green and blue-violet give Cyan (blue). Orange-red and green give yellow. When all three primary lights are mixed they produce white light.

BLEEDING The tendency of some organic pigments to migrate through a superimposed layer of paint.

BLENDING A soft, gradual transition from one color or tone to another.

BODY COLOR *see* Gouache.

CHROMA *see* Saturation.

COLOR INFLUENCE Adjacent colors have an immediate effect on each other, so that they either enhance or reduce one another's appearance. Adjacent complementary colors appear brighter because each reinforces the effect of the other.

COLORED NEUTRAL A subtle, unsaturated color, produced by mixing a primary and a secondary in unequal amounts. Colored neutrals enhance saturated colors.

COMPLEMENTARY COLOR Two colors of maximum contrast that are found opposite one another on the color wheel. The complementary of a primary color is the combination of the two remaining primary colors. For example, the complementary of blue is orange, the opposite of red is green, and the complement of yellow is violet.

COOL COLOR Generally, a color such as blue is considered cool. Distant colors appear bluer due to atmospheric effects, so cool colors are therefore said to recede.

DRY BRUSH TECHNIQUE A method of painting in which a paint of a dry or stiff consistency is dragged across the surface of the ridges of paper with a brush to create a broken color effect.

DURABLILITY *See* Permanent colors.

EARTH COLORS These are naturally occurring iron oxide pigments, i.e. ochres, siennas, and umbers.

FLAT WASH A wash over a broad area using a large brush to achieve a uniform tone.

FLOTATION The streaky effect created by lighter pigments as they disperse unevenly over the paper.

FUGITIVE Colors that are not lightfast and will fade over a period of time.

GLAZE Primarily an oil painting term, but used in watercolor to describe an overall wash in a single color. This has the effect of unifying the appearance of various colors in a painting.

GOUACHE A type of watercolor paint characterized by its opacity. Also known as body color.

GRAIN The degree of texture on the surface of watercolor paper.

GRANULATION The mottled effect made by heavy, coarse pigments as they settle into the dips and hollows of the paper.

GUM ARABIC Gum collected from the African acacia tree that is used as a binder in the manufacture of watercolor paints. Kordofan gum arabic, which takes its name from the region in Sudan from which it comes, is the main type used to bind pigments today.

HIGH-KEY COLOR Brilliant and saturated color.

HIGHLIGHT The lightest tone in drawing or painting. In transparent watercolor techniques on white paper, highlights are represented by the white of the paper. In opaque techniques, highlights are represented with opaque white gouache.

HOT-PRESSED PAPER Paper with a very smooth surface.

HUE Spectral color.

INORGANIC PIGMENTS Pigments made from chemical compounds.

LAKE PIGMENTS The pigment produced when a dye is chemically fixed onto an inert base.

LIFTING OUT The technique used to modify color and create highlights by taking color off the paper using either a brush or a sponge.

LOCAL COLOR The intrinsic color of an object as seen in an even and diffused light.

LOW-KEY COLOR Muted, unsaturated hues.

LIGHTFASTNESS The permanence or durability of a color. *See also* Permanent colors

LUMINOUS GRAYS Pure grays created by mixing unequal amounts of two complementary colors.

MONOCHROMATIC Drawn or painted in shades of one color.

Colored lights make white light

The three primaries mix to give a dark gray

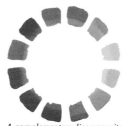

A complementary lies opposite the unmixed primary color

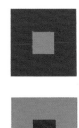

Colors placed side by side affect one another's appearance

NEGATIVE SHAPES The shape of an object created without directly painting the object itself, so that the colors surrounding the space actually become the outline of the negative shape.

NEUTRAL COLOR Colors created by mixing equal amounts of complementary colors which then cancel each other out to produce dull, neutral color.

NOT/COLD-PRESSED PAPER Paper with a fine grain or semi-rough surface.

OPTICAL MIXING When a color is arrived at by the visual effect of overlaying or abutting distinct colors, rather than by physically mixing them in a palette.

ORGANIC PIGMENTS Pigments made from natural living compounds.

OVERLAYING WASHES The technique of painting one wash over another in order to build up a depth of color or tone.

PALETTE A shallow container usually made of porcelain or plastic with separate wells for mixing colors.

PERMANENT COLORS Pigments that are lightfast and will not fade over time. The permanence or durability of a color is measured by the Blue Wool Scale in Britain, in which the most permanent colors rate 7 or 8, and the ASTM (American Standard Test Measure) in the United States, in which the most permanent colors rate 1 or 2.

PERSPECTIVE The method of representing a three-dimensional object on a two-dimensional surface. Linear perspective makes objects appear smaller as they get farther away by means of a geometric system of measurement. Aerial perspective creates a sense of depth by using cooler, paler colors in the distance and warmer, brighter colors in the foreground.

PHYSICAL MIX When a color is created by pre-mixing several colors together on the palette before application to the paper. A wet-in-wet technique is a form of physical mixing on the paper.

PRIMARY COLORS The three colors of red, blue, and yellow in painting that cannot be produced by mixing any other colors and which, in different combinations, form the basis of all other colors.

Luminous grays enhance pure colors

ROUGH PAPER Heavily textured paper, also known as cold-pressed paper.

SATURATION The degree of intensity of a color. Colors can be saturated, i.e. vivid and of intense hue, or unsaturated, i.e. dull, tending toward gray.

SECONDARY COLORS The colors arrived at by mixing two primaries, i.e. green, orange and violet.

SHADE A color mixed with black.

SPATTERING A method of flicking paint off the stiff hairs of a brush to create a random pattern of paint dots. The same effect can be created by flicking a toothbrush gently with a fingernail.

SPONGING OUT The technique of soaking up paint with a sponge or paper towel.

STAINING POWER The degree to which a pigment stains the paper and resists being washed off.

STRETCHING PAPER The process by which watercolor paper is stretched to prevent it from buckling when paint is applied. The paper is wetted, attached to a board with gum tape, and allowed to dry.

SUBTRACTIVE COLOR MIXING Color mixing with pigments. It is known as subtractive because as more colors are added, the mixture reflects less light and so appears darker. The subtractive pigment primaries are red, yellow, and blue. The physical mixture of all three in equal quantities appears gray.

TERTIARY COLORS Colors that contain all three primaries, created by mixing a primary with its adjacent secondary color. Colored neutrals are produced by mixing any two colors (*see* Unsaturated color).

TINT Color mixed with white.

TINTING STRENGTH The strength of a particular color or pigment.

TONE The degree of lightness or darkness in an object due to the effect of light.

UNSATURATED COLOR Sometimes known as desaturated color. A pure, saturated color becomes unsaturated when mixed with

Blue, red, and yellow comprise the primaries

another color into a tint or a shade. When three colors are mixed together in unequal amounts, the resultant color can be called a colored neutral.

WARM COLORS Generally, a color such as orange-red is considered warm. In accordance with atmospheric or aerial perspective, warm colors appear to advance toward the viewer, whereas cool colors recede.

WET-IN-WET Working with wet paint into wet paint on the surface of the paper.

WET ON DRY Applying a layer of wet paint onto a dry surface.

A NOTE ON COLORS, PIGMENTS, AND TOXICITY

In recommending Winsor Blue and Winsor Green (which are trade names of the Winsor & Newton Company) we are recommending "phthalocyanine" pigments; other artists' material manufacturers refer to them by their own trade names. These include Phthalo Blue and Green, Monestial Blue and Green and so on. Similarly, in recommending Permanent Rose we are recommending a 'quinacridone' pigment. Lemon Yellow Hue, another of our recommended pigments, is also known as Nickel Titanate Yellow. If you have any doubts about which pigment you are buying, you should refer to the manufacturer's literature.

We have tried to avoid recommending pigments, such as the Chrome colors, which carry a significant health risk. In the case of colors such as the Cadmiums, however, there is nothing commercially available that matches them for color and permanence. There is no danger in their use, however, nor in that of other pigments, provided artists take sensible precautions and avoid licking brushes with paint on them.

A NOTE ON BRUSHES

The brush sizes given here refer to Winsor & Newton brushes. They may vary slightly from those of other manufacturers.

A NOTE ON PAPERS

The surfaces of papers – Rough, Hot-pressed and NOT (semi-rough), vary noticeably from one manufacturer to another, so it is worth looking at several before deciding which to buy. Papers recommended in this book are of personal preference only.

INDEX

ACKNOWLEDGMENTS

Dorling Kindersley would like to thank:

Artworks

Will Adams: pp.56-57 Gabriella Baldwin-Purry: pp.18-19,
pp.44-47 Christopher Banahan: pp.24-25, pp.64-67 Sharon
Finmark: p.11, p.13, pp.16-17, pp.30-31, pp.32-35, pp.36-
37, pp.54-55, pp.58-59 Jane Gifford: p.12, and endpapers
Noel McCready: pp.48-51 Paul Newland: pp.38-41 Rachel
Williams: pp.60-61.

Picture credits

Key: *t=top, b=bottom, l=left, r=right*

p.7 *tr:* Field *A journal of practical essays, experiments and
enquiries, 1806,* by permission of Winsor and Newton,
Harrow, England p.7, 8&9: Pigments and art materials by
permission of The Winsor and Newton Museum, Harrow,
p.9 *tr:* Girtin, *The White House at Chelsea,* Trustees of the
Tate Gallery, London p.14 *b:* Turner, *Ruined Castle on a
Cliff at Sunset,* Trustees of the Tate Gallery p.15 *tl:* Alexander
African Variation, the Royal Watercolour Society Diploma

Collection, reproduced by permission of the Trustees
p.15 *tr:* John, *Little Girl in a Large Hat,* Visual Arts Library,
London p.15 *br:* Munch, *Kneeling Nude,* Munch Museum,
Oslo, Norway p.20 *t:* Nolde (attr), *Man and Woman,*
Christie's, London/Bridgeman Art Library, London,
© Nolde-Stiftung Seebüll, Germany p.21 *tr:* Cézanne, *Still
Life with Apples, Bottles and Chairback,* Courtauld Institute
Galleries, London p.21 *ml:* Rossetti, *Horatio Discovering
Ophelia's Madness,* Oldham Art Gallery, Lancs, England
p.28 *l:* Emil Nolde (attr), *Arums and Tulips,* Visual Arts
Library, © Nolde-Stiftung Seebüll p.28-29 *t:* Macke,
Woman with a Yellow Jacket, Museum der Stadt,
Ulm/Bridgeman Art Library p.21 *br:* Homer, *Gloucester
Schooner,* Visual Arts Library p.42 *tr:* Thomas Girtin,
Egglestone Abbey, Oldham Art Gallery p.42 *b:* Marin, *River
Effect, Paris,* Visual Arts Library p 43 *tl:* Homer, *Street Scene,
Havana,* Visual Arts Library p.43 *b:* Brabazon, *Benares,* by
Courtesy of the Board of Trustees of the V&A/Bridgeman
p.52 *bl:* Palmer, *The Magic Apple Tree,* Visual Arts Library
p.53 *tl:* Homer, *Palm Tree, Nassau,* Visual Arts Library
p.53 *b:* Hopper, *St Francis Tower,* Visual Arts Library p.62 *c:*
Cotman, *Doorway to the Refrectory, Kirkham Priory,* Courtauld

Institute Galleries p.63 *tl:* Delaunay, *Woman,* ADAGP,
Paris and DACS, London 1993 p.63 *br:* Hassam, *The Island
Garden,* Visual Arts Library p.68 *tr:* Francis, *Watercolour
1957,* Visual Arts Library, ARS New York pp.68-69 *b:* Ernst,
Landscape 1927, Visual Arts Library/DACS.

Thanks also to Alun Foster and Emma Pearce at
Winsor and Newton Ltd for helping with queries,
to Sharon Finmark for her hard work and long
discussions, and to Margaret Chang for her editorial
assistance.

Text researched and written by Susannah Steel.